POLAROID
THE MAGIC MATERIAL

FLORIAN KAPS

POLAROID
THE MAGIC MATERIAL

Frances Lincoln Limited
74–77 White Lion Street
London N1 9PF
www.franceslincoln.com

Polaroid: The Magic Material
© Frances Lincoln Limited 2016
Text © Florian Kaps 2016
Photographic acknowledgements on p.240

First Frances Lincoln edition 2016

A catalogue record for this book is available from
the British Library.

ISBN 978-0-7112-3750-6

Printed and bound in China

123456789

FRANCES
LINCOLN

Quarto is the authority on a wide range of topics.

Quarto educates, entertains and enriches the lives of
our readers – enthusiasts and lovers of hands-on living.

www.QuartoKnows.com

'WE CAN BE DRAMATIC, EVEN
THEATRICAL; WE CAN BE PERSUASIVE;
BUT THE MESSAGE WE ARE TELLING
MUST BE TRUE.'

EDWIN LAND, INVENTOR OF A MAGIC MATERIAL

INTRODUCTION

My first self portrait (and one of the best, according to my wife).

My first contact with Polaroid was a total disaster, further from magic than I am from being a writer. It happened in the early 1980s in a small hotel room in Südtirol as my cousin Lukas, whom I desperately hated, started to open his insanely large pile of birthday presents (his parents were freshly divorced). Suddenly he was holding a shining silver Polaroid 600 camera and a big bunch of those super-expensive instant films, smiling at me. Immediately I realized that the only way to survive this delicate moment was to affect total disinterest in his wonderful, dream-come-true technical gadget. It was obvious that my parents would never give me a camera like this (unless I could persuade them to get divorced first).

In fact it was more than twenty years until I was finally able to shake my very own Polaroid picture. It was 2004 and I was working in Vienna for the Lomographic Society, a small but very creative company dedicated to analogue photography and a small range of shoot-from-the-hip cameras. At this time the digital revolution was sweeping through photography, and we were on the search for more analogue products and technologies to expand our anti-digital business.

I ordered all kinds of analogue tools: Super 8 cameras, 3D cameras, hand-built pinhole cameras, all kinds of film and paper, and also a small Polaroid film holder for the famous medium-format Chinese Holga plastic camera, with some Type 80 Polaroid Pack films. All these things sat on my desk and one by one I started playing with them.

Together with Andi Hentschelero, a colleague, I spent some time working out how to load the Polaroid film into the bulky holder and connect it all to that crappy Holga. It was hard to find information about Polaroid films in those days, either online or offline. Nobody, including Polaroid themselves, seemed to care about these iconic products any longer. This was surprising and disturbing, given that until the late 1990s Polaroid films and cameras had been selling in millions all over the world. At last we succeeded, I pulled the trigger and carefully took out a picture that slowly developed in my hands.

Now, many years later, I am trying to work out what really happened that day. I am still trying to understand why this little reddish Polaroid

picture turned my life upside down. I am compiling the results of my long and sometimes almost desperate search for the source of this powerful magic, a magic that enchanted so many people for decades and surprisingly still works stronger than ever.

This is not a book that should end up dusty on your shelves, another well researched monograph on Polaroid's history. Especially as my friend Christopher Bonanos published his excellent version in 2012. (Christopher, thanks a lot for all your support and please forgive me for borrowing some of your words, discoveries and quotes for this book. I tried to resist but some of them were simply too delicious and too important.)

This book aims to be different, not only entertaining and maybe educating you but also seducing you. I want to inspire you to make your very own Polaroid picture soon, to shake it, carefully warm it under your arm if it is a cold day, watch it develop in the palm of your hand. And finally, when you have taken a few, to select your favourite one to become the visual highlight of this book.

You have my word. If you can get past the apparent absurdity of spending $3 for a single picture with a strange white frame then you will finally feel it. Especially here and now – in today's digital world where you can snap and share zillions of crisp colourful pictures in seconds, for free – you are likely to experience something very special. Seventy years after Edwin Land presented his first Polaroid, the same chemical reactions will still trigger emotions much deeper and more intense than any other photographic technology ever invented.

Why? I still do not know exactly why, and even after reading all the available literature and giving hundreds of talks and interviews on the topic, I am still struggling for the right words to describe this magic and the many layers behind it. But it is my firm conviction that there is no better way to discover the magic and to come close to the powerful secret 'soul' of this material than simply to look at Polaroid pictures with the right stories alongside them.

My short texts are compiled from all the wonderful stories of former Polaroid employees and enthusiasts I have had to pleasure to meet all over the world since I started this journey more than a decade ago. So I can't promise that the book doesn't also contain particles of fiction, but it is with the very best intentions of painting an honest picture.

All of the 250 carefully selected Polaroids here capture and record unique moments that I believe reveal the real attraction of Polaroid much better and more intensely than any written words could ever do. So please make yourself comfortable and let us start this visual journey.

Andi Hentschelero, my colleague and comrade, in the first Polaroid I ever took.

PART 1
DISCOVERY

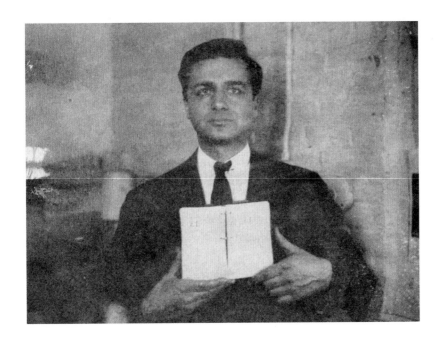

THE FIRST POLAROID

Instant photography already existed long before Edwin Land, the ingenious inventor and founder of Polaroid, went for a walk with his daughter in Santa Fe in 1943. But all these systems were not in the least magical and could really be described as 'experimental portable wet darkrooms' rather than truly 'instant cameras'. Using them was difficult, messy and delicate. Obviously, the three-year-old Jennifer Land was not aware of their existence and like anybody else taking pictures at the time, she hated to wait days, or sometimes weeks, before she could finally look at the photographs she and her father took with their Rolleiflex during their vacation.

'Why can't I see the pictures now?' she asked her father at the fireplace as they returned from their walk, triggering the development of Polaroid Instant Film. Intrigued by this idea, Land immediately went out for another walk – this time leaving Jennifer with her mother – and right away developed the principles of a completely new kind of instant photography. Thirty years later, in San Francisco, with his wife in the audience, Land recalled: 'It was a lovely day in Santa Fe. I was visiting my family, commuting across the country. There was about an inch of snow and wonderful sunshine and you could walk with no coat. And so, I went for a walk, haunted by my daughter's question, stimulated by the dangerously invigorating plateau air of Santa Fe. And during the course of the walk, the question kept coming, "Why not?" Why not make a camera that gave a picture right away?'

It was almost as though everything Land had invented up until then suddenly merged into the main principles of instant photography. Only a few hours after his daughter's legendary question, Land had already described these principles to a patent lawyer who also happened to be on vacation in Santa Fe.

'Strangely, by the end of that walk, the solution to the problem had been pretty well formulated. I would say that everything had been, except those few details that took from 1943 to 1973,' Land later recalled.

By December 1943 the first early test versions of 'Polaroids' had been developed in the lab and the project was officially launched under the codename SX-70.

It took Land and his team a little longer than expected to develop a stable process. Only weeks before the official launch, already communicated to the press, the instant images faded away after a few hours and the team had to come up with a new quick-fix chemical component to be added after the picture had developed, stabilizing it.

Polaroid film was officially born on Friday 21 February 1947 at the Hotel Pennsylvania in New York, when Edwin Land carefully peeled apart the very first instant photograph in public.

I have my doubts that this famous 8 x 10-inch sepia portrait of Dr Land really did turn out to be completely stable. I guess there are good reasons why Polaroid never made this image available for press and I have never been able to find any trace of the legendary series of 8 x 10 images made that day in any of the Polaroid archives I visited. Nevertheless on this cold and snowy day, the world of photography, the business of photography and even the idea of photography all changed dramatically.

Edwin Land carefully separating one of his famous 8 x 10-inch Polaroid prints.

Overleaf
An early series of experimental development samples from the Polaroid archive at MIT, representing countless attempts to create a stable instant photographic process.

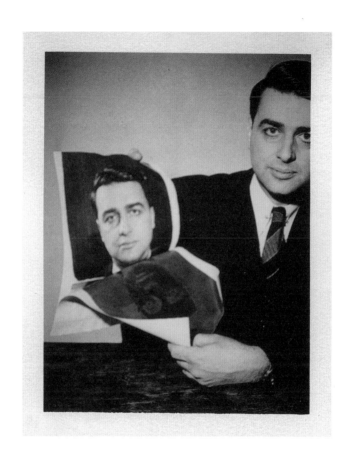

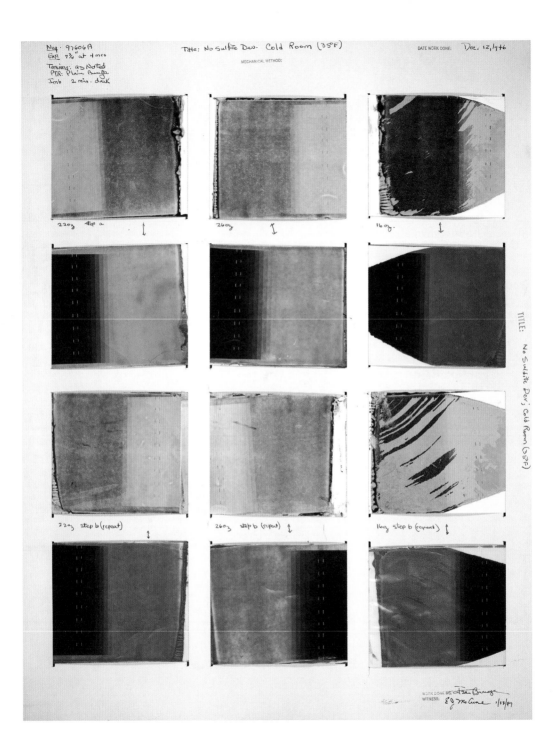

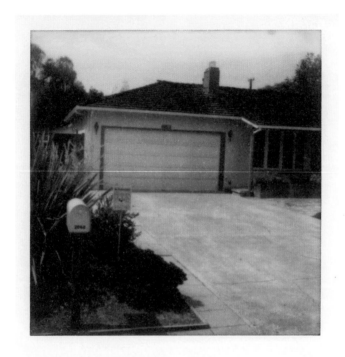

ONE STEP

As I mentioned, Edwin Land did not invent instant photography but it took a genius like him to finally develop one-step photography. Completely dry, easy and convincing enough to change the way people took their pictures. More than that, it was a system strong enough to open up new possibilities and applications to both private and business customers, producing more pictures of many different kinds than ever before.

Edwin Land was not just researching a smart and innovative instant film system. He was on the hunt for completely new tools for life, more precisely shaped to the needs of society than anything else on the market. Polaroid films and cameras have always been much more than just a clever series of ideas, patents and chemical reactions.

Land was an incredible visionary and often perfectly 'on point' when forecasting his customers' needs, long before they themselves could articulate what they were missing. Maybe the best comparison is with Steve Jobs, who often mentioned Land as one of his most important role models.

Apple was certainly not the first company to launch a portable music player when they came out with the iPod in 2001, but Steve Jobs proudly introduced the smartest system, tailored to his customers' demands and even redefining those demands with the clarity and ease of the iTunes application. For the first time, a majority of listeners could be persuaded to switch over to the new age of digital music. Apple reshaped the world of music in the same way Land had done with the world of photography several years before Jobs was born. The two men met at least twice. In his autobiography, John Sculley, who attended one of these meetings as Apple CEO, described a typical conversation between the two visionaries.

Dr Land was saying: 'I could see what the Polaroid camera should be. It was just as real to me as if it was sitting in front of me, before I had ever built one.' And Steve said: 'Yeah, that's exactly the way I saw the Macintosh. If I asked someone who had only used a personal calculator what a Macintosh should be like, they couldn't have told me. There was no way to do consumer research on it, so I had to go and create it and then show it to people and say, "Now what do you think?".'

So on that Friday in February 1947 it was finally time for Edwin Land and his team to present one-step photography to the world and to find out what consumers really thought.

It was a very important day not only for Land but also for his whole company, as the military projects that had been the main drivers for the business over the previous years had been reduced to a minimum after the war. All the company's resources had been spent on project SX-70 since the day Jennifer came up with her legendary question.

What if customers were not yet ready for this new tool? I can imagine the tension Land felt that day, slowly peeling apart the large 8 x 10-inch portrait in front of his audience. It must have been clear to him that the system still needed more time before it was really a consumer product. Most importantly, the format had to be shrunk to the size of a portable camera, which still had to be finalized and produced. The whole process of loading, exposing and extracting the film had to be established so that even first-time users could easily experience one-step photography without having to take classes or read thick instruction manuals.

Land was very aware of this and he carefully chose the location and the audience, the Optical Society of America, for his launch. Shortly before the official presentation to his audience of scientists, Land demonstrated the one-step process to members of the press in a small side room. He told the reporters that a camera to be used with the new film was being designed for mass production, price and on-sale date to be announced.

The press reaction, always a first and important indicator for a new product, was overwhelmingly positive. The 'revolutionary new camera', William Laurence wrote in the *New York Times*, 'accomplishes in a single step all the processing operations of ordinary photography'. He quoted Land as saying that the new camera 'will make it possible for anyone to take pictures anywhere, without special equipment for developing and printing and without waiting for his films to be processed'. A reporter from the *Boston Herald*, Rudolph Elie, Jr. was full of admiration: 'The finished picture is as good as anything you'd ever get back if you left a roll of film at your own corner drug store.'

Reading the newspapers in the weeks that followed the New York launch must have been a wonderful vindication. It was clear that the new technology had the potential to create a whole new industry. But it also became clear that Polaroid had to keep going at full speed to keep their promises and to introduce the first one-step instant camera film system within a month.

During the first presentations, without a camera available, the film had to be developed in a separate roller unit.

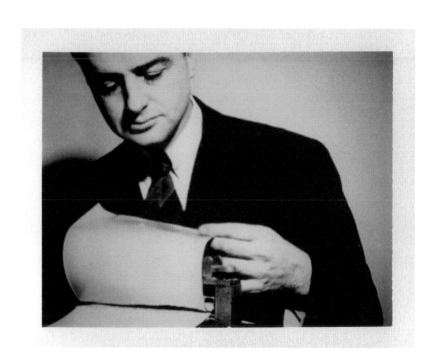

a **POLAROID** Land picture — finished in 60 seconds

a **POLAROID** Land picture — finished in 60 seconds

a **POLAROID** Land picture — finished in 60 seconds

a **POLAROID** Land picture — finished in 60 seconds

you didn't wait days for this print!

it was finished in exactly 60 seconds!

You have just seen how a Polaroid® Land Camera works. Remarkable, isn't it?

The amazing Polaroid Land* Camera shortens the entire photographic process to just 60 seconds. You click the shutter, wait a minute, then remove a beautiful, finished, black-and-white print. Photography can't be any easier than that.

We're sure you'll want to keep this picture of yourself for many years. That's why it was sealed under plastic with the Polaroid Print Coater. This Coater comes packed with each roll of film. With a few quick whisks it makes a Polaroid Land Picture a lasting print. If by accident this was overlooked when this picture was made, and you notice some discoloration, mail the print to Polaroid. It will be reprinted and returned to you free of charge.

Extra copies of this picture can be ordered from any photo dealer or from Polaroid Corporation, Box 311, Cambridge 39, Massachusetts. Price: 4 copies for 50¢ (minimum order). Please send cash, check or money order with your print.

*Named for the inventor, Dr. Edwin H. Land. Printed in U. S. A. F1521

CUSTOMERS

It had started with a simple question from Edwin Land's daughter Jennifer in 1943, and almost exactly five years later, on 26 November 1948, Polaroid finally introduced the first, long-awaited, one-step-photography instant camera. It was called the Polaroid Land Camera after its inventor, and the first model was the number 95.

The camera was quite big and heavy, weighing over 4 pounds, and not exactly a bargain at $89.75 (around $800 today). But it was clearly targeting the amateur market, offering a revolutionary tool that easily produced small, sepia-toned prints.

Criticized and disdained by professional photographers, this market strategy nevertheless worked out perfectly. Within a few hours all fifty-six available cameras (including the demonstration model) and all the available films had been sold at Jordan Marsh, a big department store in Boston. Other cities followed and by the end of the year Polaroid had earned enough cash to clear all the liabilities that had accumulated during the long, dry years of development.

Over the next five years it turned out that even the visionary Edwin Land himself had underestimated how many Model 95s the company would be able to sell. His estimate was 50,000 cameras per year: actual sales in this period were over 900,000.

Polaroid cameras quickly became the new must-have gadget for American families. Women in particular were delighted by the invitation to 'Just Press the Button' and receive a 3¼ x 4¼-inch image of their loved ones within seconds. From that day on, millions of family albums were filled with Polaroids of important events, redefining the culture of picture taking. Land's dream of not just inventing a camera but establishing a completely new tool for life, to change and enhance the way people take pictures, had become a reality.

A selection of early sixty-
second experiences.
The ease and spontaneity
of using Polaroid meant
that it was an immediate
success with American
families.

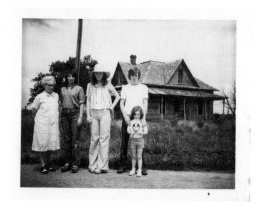

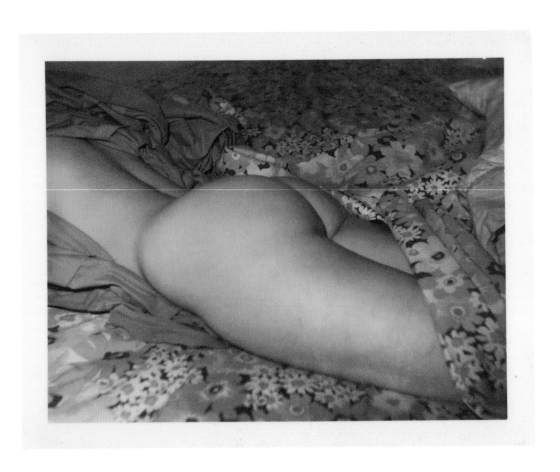

EROTICA

A found selection of special erotic moments. This was the beginning of private erotic photography, taken without the necessity of a darkroom or a professional lab, without having to even leave the intimacy of the room.

There was one essential aspect of this new kind of photography that Land had probably not taken into account. Certainly it was never mentioned in any of his famous visionary talks describing the potential of instant photography. In fact Polaroid never touched this topic in all the decades of its existence, even if it soon became obvious to everybody that it was responsible for a high proportion of annual sales.

I am talking about private erotic pictures. The impact of Land cameras on this sensitive sexual human behaviour was immense. It really started it all, because before Thanksgiving 1948, the privacy and intimacy of picture taking was strictly limited to individuals who owned a fully equipped darkroom and had the expertise to use it. Everybody else had to accept the disturbing fact that their images were shared with strangers the moment they dropped their films at the counter of their drugstore or professional development lab.

Suddenly all of this was gone and for the very first time in the history of photography people could capture the tension and fragile beauty of sexual moments without leaving the room. And even better than that: the erotic Polaroid became part of the moment itself, even heightening the experience as visual proof of total freedom and independence.

It does not feel like a crazy overstatement to compare the sexual impact of instant photography to the invention of the Pill in 1960 (although Polaroid cameras were available to anybody right from the start, compared with the Pill, which for its first twelve years was only legally available to married women).

Polaroids did not just change erotic photography. Over time, these billions of erotic pictures somehow also made their way into the soul of Polaroid, becoming a very important component of its overall flavour. You best experience it by just looking at some classic Polaroid portraits. Many of these images do have a special intimacy attached, even without any explicit nudity or sexual content. Somehow Polaroids make you feel much closer to this person, almost like being in the same room, sharing the same moment.

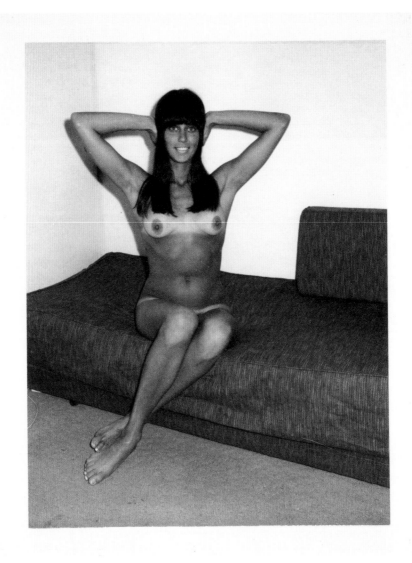

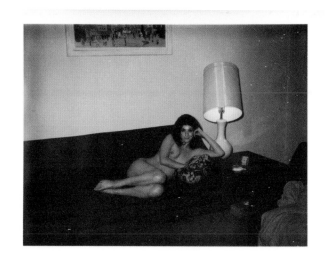

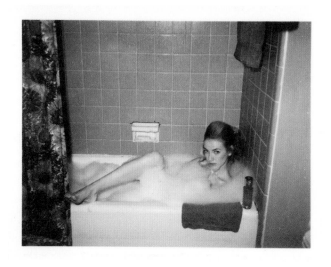

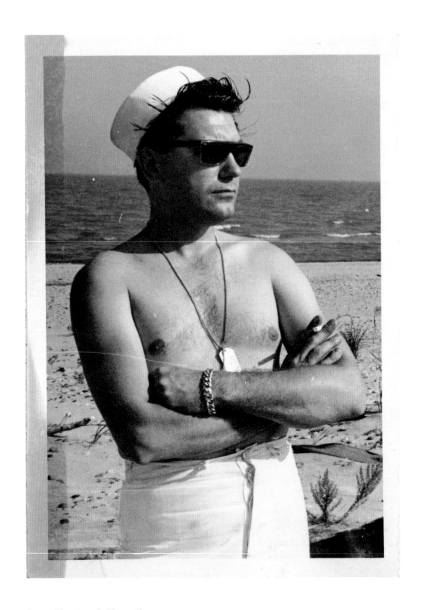

Even without explicitly erotic
content, Polaroids never lose
their special touch of intimacy.

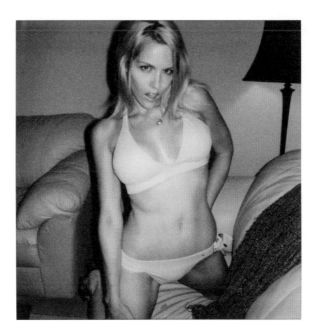

Luigi Lomani (signature)

According to a beautiful rumour, Gene Simmons, the iconic bass player of KISS, has a collection of more than a thousand Polaroids, as he was in the habit of taking a picture of each and every 'love affair' on tour. (Mr Simmons, if you ever happen to read this, first of all there is good news: we restarted production of Polaroid film, so it is available again whenever you need it. Secondly, I would be more than pleased to organize a big Polaroid exhibition and catalogue of your archive if it really does exist. Please call me!)

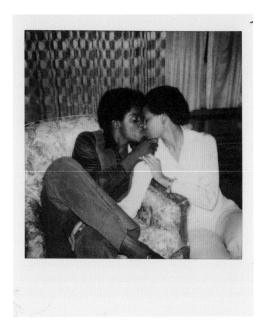 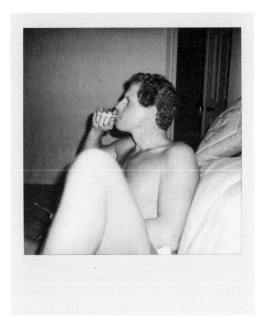

A sexy collection of
found Polaroids. The
SX-70 system, introduced
in 1972, was a perfect tool
of the sexual revolution.
Even if Polaroid never
acknowledged it officially,
private erotic photography
was a huge driver for
their business.

Me in shape 11-87

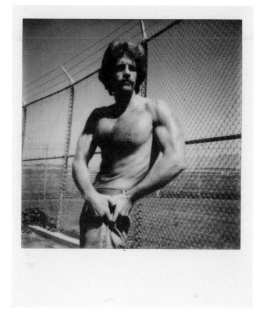

QUALITY

'Ideally, all that should be necessary to get a good picture is to take a good picture', Land explained in a speech to the Royal Photographic Society in 1948. But what exactly defines a good picture?

From the very beginning this question was a heavy burden on Edwin Land's shoulders, especially as he was a true perfectionist always trying not just to meet but to surpass all the existing standards set by his competitors.

Several times Polaroid faced severe quality challenges because of the outrageous complexity of the very delicate chemical processes on which it is based. Like any chemical process, a Polaroid is heavily influenced by the surrounding temperature, humidity, atmospheric pressure and a host of parameters that can never be standardized, especially with a product that is meant to be used all over the world in all climates and seasons.

Polaroid chemists were lucky enough to find a fixation dye at the last minute, just a few days before the official launch, but they had to overcome many critical setbacks throughout the decades, basically every time they introduced new materials. The first 'black-and-white' film could rather be described as 'sepia-toned', and it was really worse than that – Polaroid was forced to mount a large recall campaign in late 1949, when it was discovered that the first generation of instant photographs would irresistibly curl up, 'magically' jumping out of photo albums.

Polaroid never quite shook off the reputation that their photos were unstable and subject to fading, even if by the end of the 1970s the new generation of Polaroid films were not only much faster to develop but also of amazingly enduring quality. This false reputation would have caused the collapse of any other film company, but there was another important attribute that people tend to forget when talking about Polaroid, especially nowadays in the digital age: Polaroids are intimate instant originals. Every one of them is a unique physical artefact, the product of one particular moment.

A selection of found
Polaroid images, featuring
unique characteristics
like fading, coating
defects and discolouration
that have often wrongly
been misinterpreted as
bad quality.

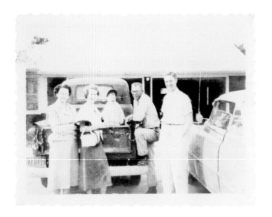

Even the introduction of the acclaimed new integral SX-70 film in 1972 had serious glitches. Photo dealers nationwide reported that the battery included with each pack was a dud in one out of ten cases. As if that were not enough, the film, which for the first time in history enabled the photographer to watch the image slowly 'fading in', was not completely stable. It had a tendency to crack and fade out, especially when directly exposed to bright sun and intense humidity.

Once again, Polaroid engineers didn't stop until they had a better solution. With the introduction of the new Time Zero film, not only did stability improve dramatically but the development time dropped almost to zero.

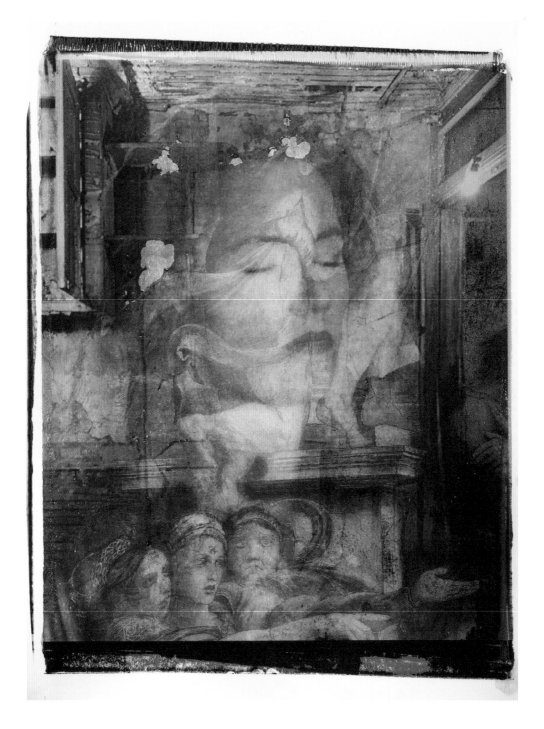

INSTANT ORIGINALS

A large-format Polaroid by John Reuter, dissolving the border between painting and photography.

My friend and fellow analogue enthusiast Professor Achim Heine once wrote in a small essay on the speed of images: 'When Edwin Land launched his Polaroid Land Model 95 in 1948, he introduced a fork in the history of photography. While small-format photography moved on from one outstanding optical achievement to the next, Land focused almost exclusively on the peculiar quality of the photograph's instantaneity.... There was no other image in the world that was more quickly in the hand, on the table, in the album than a Polaroid. This was the strongest argument against classical small-format photography. Every Polaroid was instantly available – as an original, a memory made manifest, a past made present.'

Polaroids, with their fragile nature and unpredictable behaviour, are true one-of-a-kind originals. That is what it is all about, what clearly sets them apart. Traditional photographs are by definition reprints from a negative; they can be reproduced in different formats and characteristics over and over again. Traditional processing takes hours and requires a professional darkroom that can be adjusted to perfect working conditions.

How can you compare that to a poor little Polaroid exposure that has an integrated 'small darkroom', as well as all the chemistry it needs, separated by thirty ultra-thin layers and controlled by a built-in mainly pH-driven chemical 'management system' activating and de-activating all the development steps in just a few carefully orchestrated minutes? Why not simply forget about comparisons with the so-called 'standards' of a completely different product family? Why not just forget about this human instinct to define a quality for everything, quantified in numbers and the sort of sophisticated terminology that nobody without a Cambridge degree in chemistry really understands?

Why not more precisely and honestly compare a Polaroid original to a painting, rather than a traditional photograph? In many ways they are much closer in complexity and overall character. Who would ever be surprised by the fact that an oil painting changes when exposed to direct sunlight or high humidity? Why not respect and accept a Polaroid as a one-of-a-kind chemical painting, produced by light in just a few seconds? Does that not sound like magic?

Two chemical light paintings,
also known as Polaroids.

I could never Describe this
Scene—My Front Porch S.M.
12-1-77 (At Sunset)

POLAROID ART

From the early days,
Ansel Adams tried
convincing Edwin Land
to introduce larger-
format instant film.
This resulted in the
production of high-
quality black-and-white
4 x 5-inch film.

Now that we have refused to compare apples to bananas and happily failed to nail down scientific parameters for defining Polaroid's quality, let's move on to the delicate question of how to define the art of Polaroid.

Whatever art may be, the essential importance of its multi-layered impact on his invention was apparent to Edwin Land. Steve Jobs once remarked admiringly: 'Not only was he one of the great inventors of our time but, more important, he saw the intersection of art and science and business and built an organization to reflect that.'

In 1955, Land hired the famous photographer Ansel Adams as artistic consultant. This marks the beginning of a close cooperation between Polaroid and the art world, which resulted in the foundation of two legendary Polaroid Collections, in the US and Europe.

I think Land understood that the real potential of his invention should be defined not by the brand, but rather by the people using it: passionate photographers all over the world who were filling the white borders of a Polaroid with the most important and beautiful things in their lives. This is the moment when a sophisticated but basically soulless chemical material awakens and transforms into a unique and powerful product, lifting Polaroid into an emotional sphere that can only be compared to peak Apple under Steve Jobs.

I doubt that Land's real reason for employing Ansel Adams was for the professional improvement of the materials, though it was often claimed that new film products only made it to the market when Adams gave his approval of their quality.

Of course Land carefully read and discussed the iconic photographer's detailed notes and field reports and even followed his advice, fulfilling Ansel's long-term wish for larger formats by introducing 4 x 5-inch film. But I think that Land's real genius in supporting the most creative photographers of his time with Polaroid film and cameras is based on his brilliant strategy of defining Polaroid by displaying the best of those artists' work. These were images better suited than anything a marketing agency could come up with to inspire people to get creative, becoming artists themselves at the click of a button.

Some artists were intrigued by instant photography at first sight. Andy Warhol became perhaps the most famous Polaroid brand ambassador after Ansel Adams, shooting his famous portraits all day and night with his crazy Polaroid Super Shooter.

But many others were sceptical and took time to discover the magic of this new material. It is a fact that Polaroids have their own will and you can never precisely control them. They want to be conquered, demanding all your concentration and your openness to chance, demanding that you are always ready to switch from action to reaction.

This was a completely new kind of dynamic in photography, only made possible by the immediate appearance of your images. As Land once described it in *LIFE* magazine:

> In the other arts there is always a continuous interplay between the artist and his art. He has the painting or sculpture before him. What we have tried to do is to provide a new photographic medium for 'artistic expression' to anyone with only a reasonable amount of time. By giving him a camera system with which he need only control his selection of focus, composition and lighting, we free him to select the moment and to criticize immediately what he has done. We enable him to see what else he wants to do on the basis of what he has just learned.

In reality this challenge of 'controlling' Polaroid film often proved to be impossible and there was a lot to criticize and a lot to learn before real art was achieved. As Maurizio Galimberti, an Italian photographer, once explained to me, 'Starting to shoot with Polaroid feels like dancing with a stranger, constantly stepping on each other's toes. But whenever you finally manage to find a groove it is hard to stop moving and you will definitely save the last dance for this one-of-a-kind material.'

A self portrait of the Italian photographer and Polaroid dancer Maurizio Galimberti.

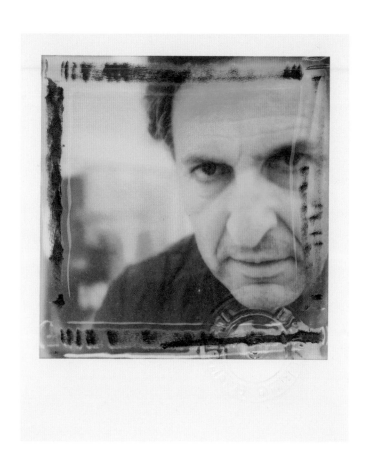

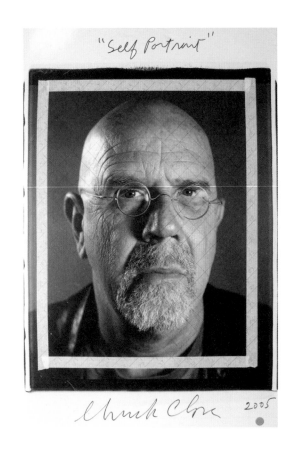

"Self Portrait"

Chuck Close 2005

Chuck Close, *Self-Portrait*, 2005–2008, Polaroid photograph mounted to foam core with ink, graphite image and tape and paper, 36 x 26 inches including mount.

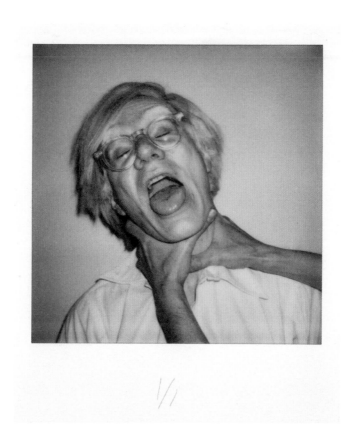

Andy Warhol became one of Polaroid's most famous brand ambassadors with his self-portraits and party shots. Andy Warhol, *Untitled*, 1974, internal dye diffusion transfer print, 4¼ x 3½ inches.

For many serious photographers, their first dance with Polaroid was the convenient and unromantic practice of taking test shots before switching to 'real' photographic high-quality materials. Especially in super-expensive studio settings, photographers wanted to get a quick glimpse of how the final pictures would look with regard to lighting and composition, and they used Polaroids as test materials. Most of these ended up as trash only a few minutes later, their job done.

But not all photographers trashed their Polaroids and I will never forget the day the amazing Jasper Zwartjes told me the story of how he rediscovered a box full of large-format test Polaroids from fashion shoots taken years before.

It was a crazy experience looking at all these Polaroids because they really zoomed me right back into the scene of the shooting. It almost seemed to me as if I could smell the studio again and feel this crazy tension from that long-gone day. Maybe because they really had been there with me? Anyhow, I immediately compared the Polaroids to the final prints from the same shoot, taken on classic large-format film and developed in a professional lab. And I have to say that compared to the Polaroids all of them looked really flat and almost sterile.

Again it seemed to be Polaroid's instant originality and the fact you can hold the finished pictures right there in your hands that made all the difference, almost like instant and valuable memorabilia. Not only capturing and preserving the light waves but also folding all the other kinds of energy and emotions floating around at that very moment into the picture's chemistry.

8 x 10-inch Polaroid by Jasper Zwartjes, originally taken as a large-format test shot during one of his fashion shoots, and saved from the trash.

There is another aspect to this instantaneity: it is completely impossible to fake or alter a Polaroid picture. Artists have to think hard and often dive deep into the field of optical illusions and legerdemain if they want to create images that are basically impossible. One of my favourite examples of this kind of picture, for sheer brilliance, is the Polaroid called *Cinema 2* by Patrick Nagatani. Fantastic at first sight, it becomes an even more impressive masterpiece as soon as you realize that every little detail of this image had to be real in order to appear this way in an instant photograph.

I cannot understand why Polaroids are not by far the most expensive photographs in the art market. We are talking about unique originals. You can be 100 per cent certain that the artist really has touched this picture, and that it exists in precisely one version, something that you can never be sure of when purchasing a traditional photographic print. So if you want a piece of advice from an acknowledged expert on the biology of spider's eyes (i.e. me) of how to invest your money in the strange world of art collecting, go and buy Polaroids by photographers you adore, or just Polaroids that you fall in love with on eBay. There are still plenty out there, but as soon as the art world finally gets it, it will be too late.

The magic of this picture from Patrick Nagatani is the fact that every little detail had to be arranged in reality, with no possibility of altering the image after it was captured.

NAGATANI 1986

The only formats that really established themselves as valuable art pieces are the giant 20 x 24-inch Polaroids that Polaroid introduced in 1976. Originally this camera was demanded by Edwin Land to impress on shareholders the power of large-format Polaroid photography at the annual meeting where he was planning to launch 8 x 10 film. But soon artists were discovering these incredible hand-built cameras produced by the Polaroid workshop. Five cameras in total were used by outstanding artists around the world to create magic images unlike any other.

Because of the success of this project, Land was tempted to go one step further: 'I would like to see a life-size reproduction of Renoir's *Le Bal à Bougival*. It's 39 inches across, and our film is slit at 40 inches – we can do it.' And so they did it, building one super-giant camera producing images that were 40 inches wide. It was best described as a room you could walk into. On one side there was a giant lens weighing more than 50 pounds and on the other side a complicated film holder with an integrated Black & Decker vacuum cleaner to suck the paper flat. This camera was a real adventure to use as it required two assistants working inside the machine in complete darkness wearing night-vision goggles.

I believe that, despite all this complex and sophisticated artistic equipment, only available and affordable to a very small group of artists, Land very much identified with Joseph Beuys' famous saying 'everyone is an artist'. Of course, Beuys never meant to suggest that everyone could or should be creators of traditional artworks. Rather, he meant that we should not see creativity as the special realm of artists, but that everyone should apply creative thinking to their own area of specialization, whether it be law, agriculture, physics, education, homemaking or the fine arts.

By making it so easy to create unique light paintings, Polaroid opened the creative world of photography to many people who never would have considered themselves artists. This for me is the real art in Polaroid and the reason why you will mostly find Polaroids in this book from artists you have probably never heard of before.

Elsa Dorfman and her beloved 20 x 24 camera, one of only a handful ever made. Elsa not only created an incredible portfolio of images over time, but her passion and support has kept this giant format alive today.

me and Camera #3, in NYC.
April 13, 2007.

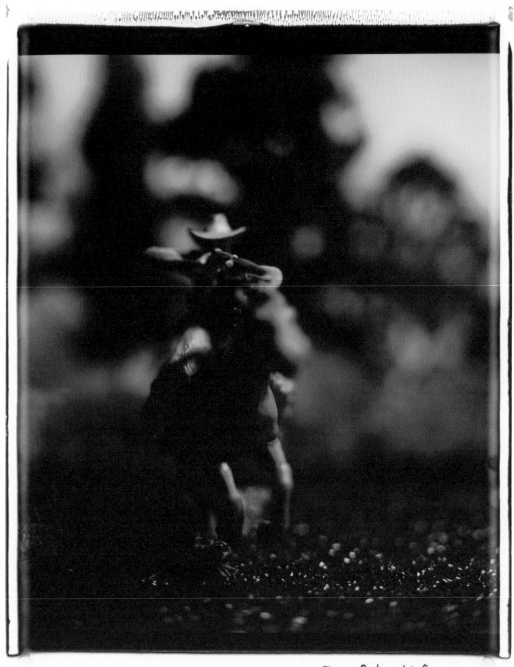

David Levinthal 1989 AP

Left
20 x 24-inch giant
Polaroid image by David
Levinthal, famous for his
incredible macro shots of
little toy figures, celebrating
the possibilities of this
medium.

Right
Max Rada Dada, for me
one of the most
underestimated Polaroid
geniuses, famous for his
series of experimental giant
Polaroid works, many of
which were unfortunately
destroyed in a fire. He
describes his process as
'submitting my ideas and
concepts to the Polaroid
camera with its chemistry
and physicality'.

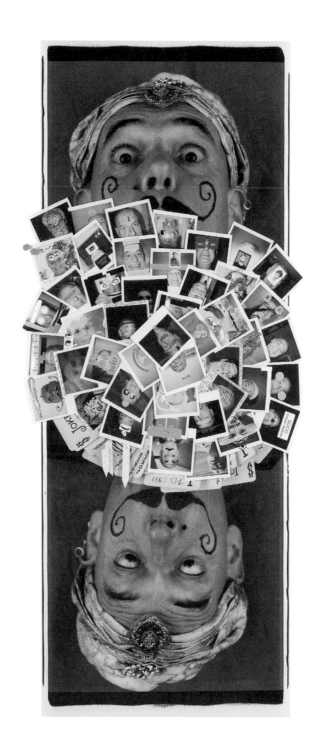

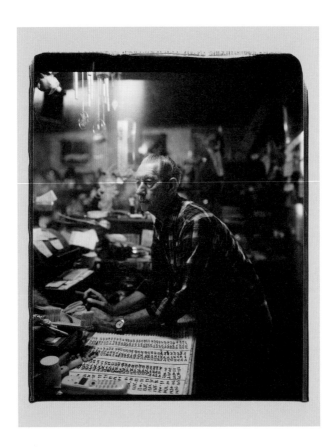

Jennifer Trausch was one of the first photographers to lift the
giant camera onto a truck, leaving the studio environment to shoot
an incredible series of Americans in their natural environment and
places of work, melting their visions and dreams into the chemistry
of this magic material.

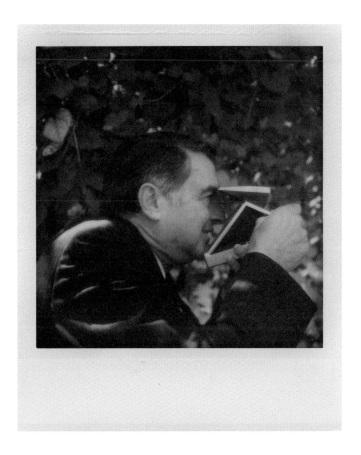

There must have been thousands of Polaroid art books published through the years. The one I would most like to see would contain the private Polaroids of my favourite Polaroid artist of all time: Edwin Land. Unfortunately, not a single one of his pictures seems to have survived but he must have been known as a passionate photographer. The day he finally had to leave Polaroid, he received his very own custom-built 20 x 24 camera and one of my dreams is to discover one of the giant photographs he made with it.

CREATIVE TECHNIQUES

A large emulsion lift
from the well known
photographer Beppe
Bolchi, where the
gelatin-like picture layer
is dissolved in water and
carefully lifted onto a
soft piece of craft paper.

Ansel Adams and a league of excellent traditional photographers pushed Polaroid to larger formats, deeper colours, crisper contrasts and even the introduction of the first positive/negative Polaroid film format in 1958. In the same year, these artists' images also started to define the face of Polaroid, as beautiful full-page adverts revealed the inspirational beauty of one-step photography.

But there was another wilder and more experimental approach to this new material. Whether they were artists or not, some people were just crazy enough to dive deeper into Polaroid's chemistry without fear of getting their hands dirty. They were eager to lift Polaroid art to a new level, creating photographic results unlike any other. They surprised Polaroid with the discovery of several new techniques that quickly became additional selling points.

It all started with two 'hacks' for the classic Polaroid Pack film formats. These are the formats where you have to manually separate the positive from the negative after a certain time. With the negative you can perform something that is called 'image transfer'. Basically this means that you separate the negative and the positive a little earlier than recommended, so that not all the activated dyes have found their way from the negative to the positive. Now you can put this negative – still containing a lot of the exposed picture information – upside down on any surface you like, but preferably a soft piece of paper. Carefully press it and slowly remove it and the picture will magically peel off and stay on the new surface.

Another very popular technique is called 'emulsion lift'. This is performed with the almost finished – but still wet – positive side of peel-apart film. Again you can separate the gel-like picture layer from the base, but this time you have to put a little more effort into the procedure. Put the image in warm water and wait some minutes until the picture layer comes off and starts floating on the surface of the water. Watching this process itself is an incredible experience and you will hardly believe how cool it looks to see your own photograph floating like a fragile piece of colourful, transparent skin. It feels like you are making something closer

to a painting than a photograph, especially when the image is carefully transferred to a beautiful surface or object or even just left floating inside a bottle.

When the new integral film was introduced in 1972 artists started playing with the idea of finally dissolving the borders between photography and painting altogether. SX-70 film, with its new chemistry, was thicker and softer than any of the classic peel-apart film materials, at least in the first minutes after the image appeared and the grey curtain colour vanished. This was caused by the new arrangement of the essential film layers: the positive and the negative were sandwiched together from now on, under a protective layer of clear plastic.

With the blunt end of an ordinary pencil or pen artists started to draw directly on the image, moving the fresh paste which included the recently activated colour dyes. Mysteriously, the photo chemistry started to behave like fresh oil paint and the whole picture finally became an incredible symbiosis of visual effects that can hardly be described and had never been seen before.

On the subject of paintings and Polaroids it is time to introduce my friend John Reuter, who plays an important role among the most creative and innovative Polaroid artists of all time. John became famous for his virtuoso Polaroid transformations, extensively developing and using techniques even more radical than the ones mentioned above. He not only created an outstanding body of work defining the magic of Polaroid and inventing a variety of special techniques including 'SX-70 Construction', but he also never tired of teaching thousands of interested photographers how to fall in love with this material, pushing it beyond the limits of traditional photography. (And last but not least he even ended up saving the legendary 20 x 24 studio over and over again, each time Polaroid collapsed. It is still standing strong today.)

A manipulative experiment with the different layers of integral film executed and displayed by the artist Eduardo, using the original parts of the photo frame as a canvas for the emulsion lift.

John Reuter is famous for inventing all kinds of complicated techniques.
His Polaroid Constructions create surreal images unlike any others, combining
emulsion components with collage elements or even acrylic paint.

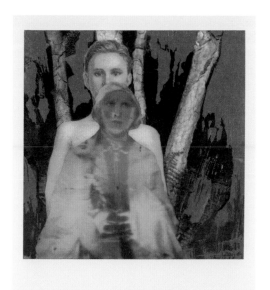

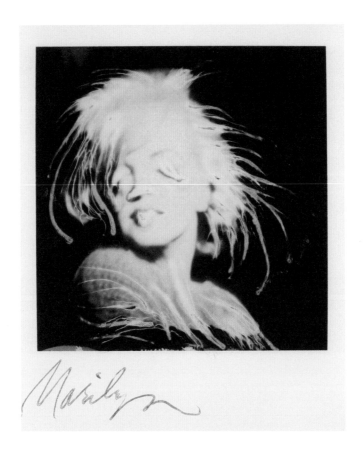

In 1980, while on holiday in Turkey, Ralph Steadman discovered the
malleability of the Polaroid before it set and began distorting and
remoulding the faces of the rich and famous. It was a new form of caricature
and one that forced an instant reaction from the artist with little time to
consider the final image before it irrevocably set. Here are Steadman's
'Paranoids' of Marilyn Monroe and Richard Nixon.

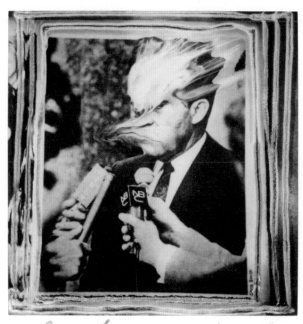

Richard NIXON

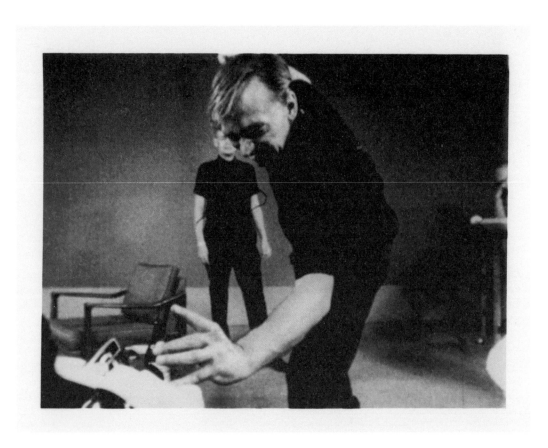

THOUGHTOGRAPHY

Ted Serios at work, exposing his thoughts on Polaroid film. The intense sessions often needed several hours and several packs of beer.

Travelling through Polaroid's history in an attempt to reach the heart and soul of this unique material, we have to stop off at the famous case of the former Chicago bellhop Theodore Judd 'Ted' Serios (1918–2006). The performances Serios became famous for in the 1960s were truly impressive, and raised questions about the commonly accepted limits of the human mind.

He had the unique ability to produce 'thoughtographs' on Polaroid film. He would roll up a piece of paper into a short tube at the start of each session and hold this 'gizmo' to the lens of a Polaroid camera. Then he aimed the camera at his forehead. The exposure thereafter was made by an assistant upon a signal from Serios: a snap of the fingers or a verbal command.

Many of these 'thoughtographs' are carefully archived in the Special Collections at the University of Maryland, Baltimore. Some of them show images of an object or place that was not there. (Others, called 'normals', depict what one would expect all of the photographs to show: Ted's face or shoulders, or even just the room behind him.) It was the usage of Polaroid material that meant this phenomenon did not just end up in a supermarket tabloid but was carefully examined by one of America's most eminent psychiatrists, the Denver-based Jule Eisenbud.

Emily Hauver, curator of exhibitions in Maryland, explains: 'It falls into a long history of using the medium of photography to try to depict or capture or collect evidence of paranormal events. The case of Ted Serios is unique in that he used Polaroid cameras to produce his imagery. Polaroid cameras produce original photographs on the spot, eliminating the opportunity for trickery to occur through printing techniques employed in the darkroom.'

Simply because it is impossible to fake a Polaroid, Jule Eisenbud invited Ted Serios to Denver and spent three intense years with his mostly drunken subject, investigating his long and exhausting performances with incredible meticulousness. He summarized his surprising findings in a book, *The World of Ted Serios: Thoughtographic Studies of an Extraordinary Mind*. The book earned Serios a lot of recognition, but that fame also

attracted plenty of sceptics who didn't quite share Eisenbud's belief in thoughtography, even though he had gone to great lengths to account for variables that might indicate a fraud.

'Ted said that when making thoughtographs, he didn't see the image in his mind or his imagination prior to making the exposure,' Emily Hauver says. 'He said that it was more akin to being a kind of portal through which this information or imagery simply passed . . . Even if you don't believe in the paranormal, the rather compelling way in which Ted made his images allows for appreciation of these events, at the very least, in terms of performance — an authentic, very powerful performance.'

X-Files producer Chris Carter has recently signed up the film adaptation rights to Dr Eisenbud's book, but if you can't wait to watch Ted performing, you can find impressive original video footage online.

(Left) Ted Serios standing in the doorway of the Williams' Livery Stable in Central City, Colorado. This photo of Ted was taken after he produced thoughtographs of the building during sessions at Dr James Galvin's house, April 1965, among them the blurred image (right) of a brick building with arched windows and doorways. The words 'Livery' and 'Feed' are visible over the centre arch of the building.

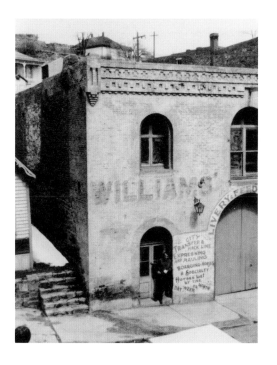

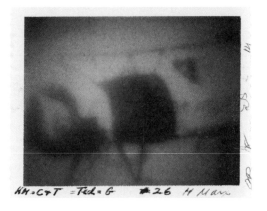

HM=C+T =Ted=G　　#26　H Man

Dr Eisenbud often asked Ted to reproduce target images in his thoughtographs. The image on the left is a target and on the right is Ted's thoughtograph.

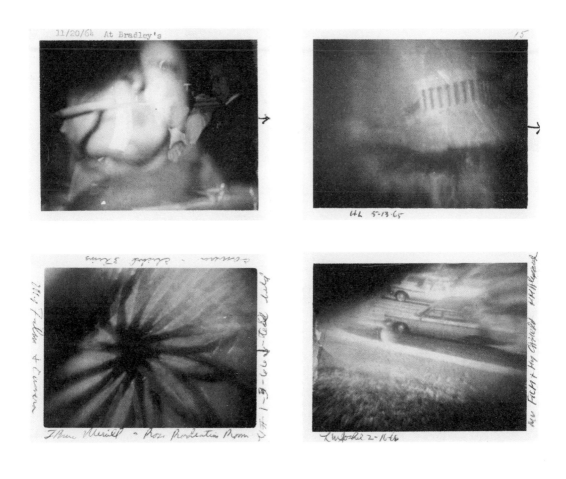

A selection of Ted's
mysterious thoughtographs.

SHARING

A Polaroid used as a
postcard, showing how
an immediate snapshot
can become a valuable
way of sharing moments
just by adding a stamp.

When Edwin Land proudly showed his first sepia 8 x 10 portraits to reporters in that small hotel room in New York, he also introduced 'picture sharing'.

Until then, photography was all about 'taking a picture': framing your target, pulling the trigger, capturing the light waves your object emitted in a black box and then taking this captured moment away with you.

Instant pictures meant that for the first time the photographer was in the fortunate position of being able to share the picture – that just-captured moment – with their subject right away, instead of taking something away from the scene. This difference is of incredible importance, especially if you take pictures of people who have never seen a camera before.

Since then, a Polaroid camera with at least enough film to shoot two images – one to stay with the subject – has been an essential piece of equipment for countless anthropological expeditions around the world. People's fear that their soul might be captured in these black boxes changed to happiness and trust as they could watch their own images develop in their hands. They could keep this visualization of a shared memory.

Of course this easy and intuitive way of sharing special moments also worked outside of the field. Many companies made use of the brilliant social aspect of instant photography by ordering Polaroids with their logos printed on the white frame of the film. Then they created emotional events and invited everyone there to shoot Polaroids. As a result everybody who was part of the event took home some instant pictures, and most likely shared them by putting them up on their fridge. Neatly branded with the company's logo, these treasured memories blended an individual's positive emotions with the brand's identity.

The unquestioned world champion of this concept was McDonald's, inventor of the famous children's parties. These parties burned more than a million Polaroid pictures every year for decades.

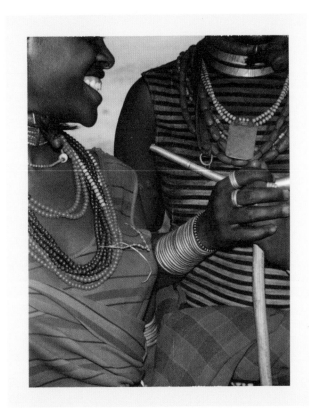

Field Polaroids from
Alfred Weidinger, shot
and shared on the streets
of southern Ethiopia with
the famous Big Shot
camera as part of a series
of fifty portraits.

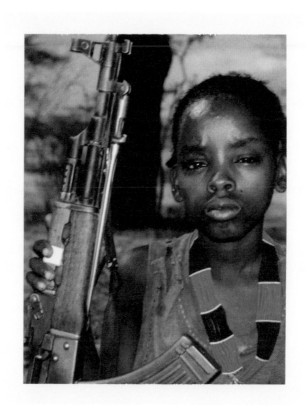

Roserita Beach, Baja Cal., Mexico 3/24/66

Different ways of
converting Polaroids into
branded mementos, to
share the moment and
keep it forever.

ENTERTAINMENT NITELY

PAGE FOUR

COCKTAIL LOUNGE
4125
MARTIN LUTHER KING, JR.
BOULEVARD
LOS ANGELES CALIF. (213) 296-8009

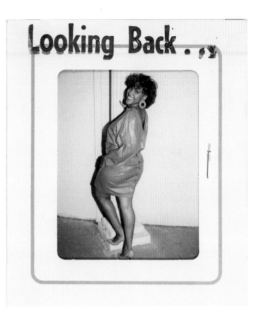

Looking Back...

DESIGN & FASHION

Starting in 1957, Paul Giambarba redefined the look of Polaroid, introducing iconic style elements, most importantly the rainbow colour scheme.

Looking back, Polaroid still stands out as arguably the most fashionable and iconic design brand ever to come out of the US, at least until Apple came along. This is especially remarkable as since 2004 the new owners have transformed Polaroid into no more than a licensing company, staffed mainly by lawyers.

Even Lady Gaga, famous for working with the most brilliant creative minds of our time, answered the call from Polaroid to become their creative director in 2009. She proudly texted her father, 'FINALLY I have a real job.' But even though she maintained her poker face, she must have quickly found out that her love for Polaroid was based on something that peaked in 1972, and had already started to fade by 1978.

In the very beginning, design and fashion were not really of interest to Edwin Land. This came as a surprise to me, as I had imagined Land to be in the same design-obsessive league as Steve Jobs. This assumption collapsed over the course of a lunch with Polaroid's first art director Paul Giambarba in 2008. 'When I was invited to join Polaroid in 1957, it was clear that Edwin Land did not really care about the packaging of his films. Even the delicate question of branding the instant film had not been clearly solved, as the Polaroid brand still only seemed to be connected to the products using polarization filters. And people always had trouble pronouncing it correctly.' Paul amazed me. 'Most of the products were introduced under the name of Land himself, as Land Film and Land Cameras. There was a rumour – very likely true – that the main colours of the brand (grey and red) were chosen because of Land's "romantic feelings" for MIT [Massachusetts Institute of Technology] who used almost identical colours. All of this was a total disaster, especially when compared to the flashy, modern, bright yellow packaging of big brother Kodak.'

Although it had been a brilliant strategy to build the brand identity through showcasing carefully selected Polaroid photography from all kinds of sponsored artists, it was time to clean up the mess and develop an innovative product design strategy to complement the photographs.

Paul Giambarba in front
of his famous uppercase
typeface logo, based on
New Gothic.

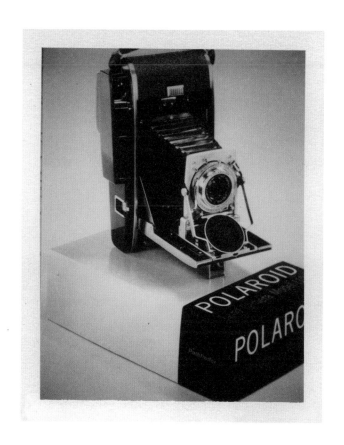

One of Paul's first jobs for
Polaroid was introducing
a highly simplified new
packaging line for Land
cameras.

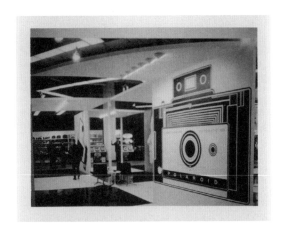

Over the years, Paul Gianbarba's work made Polaroid
one of the world's best-known design brands. He also
introduced symbolic line drawings of all the new cameras,
to be used in Polaroid's presentations, exhibition booths
and point-of-sale materials.

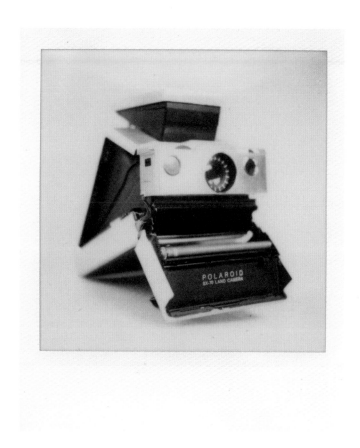

For many people, myself included, the SX-70 camera introduced in 1972 is the best-looking and most iconic camera Polaroid ever produced.

The ultimate breakthrough, finally connecting Polaroid to the world of cutting-edge design and fashion, happened in 1972 when Edwin Land proudly introduced his masterpiece, the iconic SX-70 camera. This foldable SLR instant camera was not only packed with new inventions and innovative technologies, it also was an incredibly good-looking design object, made out of high-value materials with a shining chrome body and fine leather covers. Nothing remained of those first bulky 4-pound Model 95 cameras from twenty-four years before. For many people, the SX-70 is still the most beautiful and most innovative camera ever produced. Land asked the most acclaimed designers of the time, Ray and Charles Eames, to produce a movie introducing the SX-70 camera and all its new features, firing the new Polaroid integral film into the hearts of creative people around the world.

With the SX-70, Polaroid transformed the market in the same way that Apple did many years later with the iPhone, introducing a high-quality must-have item that was more than just a gadget. Finally Land had the perfect 'tool for life' in his hands. He had found astonishing solutions to all the problems he couldn't solve on his walk in 1943. The new integral film system finally made the process of picture taking into the one-step process Polaroid had been advertising for years, as for the first time you did not have to separate the positive from the negative in order to see the picture. All that was really left for you to do was to push the button and fall in love with the Polaroid slowly appearing in your hands. This was what Edwin Land had been dreaming of for all those years. Suddenly everything else just seemed like small and necessary steps on the road to the masterpiece he was proudly holding on the cover of all the world's most important magazines (and on the cover of this book, originally shot for *LIFE* magazine).

This was the moment when even the most sceptical people started to shake a Polaroid picture. New applications started popping up all around the globe, not only boosting sales of cameras, but even more importantly the consumption of instant films, the main driver of Polaroid's business and the pulsing blood of Polaroid's magic.

Not even the most sceptical photographers could resist the magic of the new SX-70 system, developing those little colourful prints in their hands.

Even the white frame around every integral picture, so strange-looking at first sight, soon became accepted and remains one of Polaroid's best-known brand attributes. The little white rectangle below the picture became widely used as a 'message board' where you could enhance your Polaroids with personal messages. It is hard to believe that the frustrated development team spent countless nights and a whole lot of effort in search of a better solution for this shape they hated so much. In the end they had to give up: the lower part of the frame simply has to contain the little pod that holds the developer, which is squeezed between the positive and the negative layer as soon as the camera ejects the picture.

This was the moment that Polaroid cameras also entered the world of fashion, not only as a chic accessory but also as an essential tool for photographing every model at fashion shows, archiving every look and style. After millions of these catwalk and casting Polaroids, the fashion industry was bereft after the termination of classic Polaroid film in 2008. Even if most fashion designers have converted to digital these days, everybody still refers to these mood shots as 'Polaroids'.

My favourite Polaroids using frames as messageboards. Polaroid engineers fought to get rid of the strange broad white frame, which turned out to be a famous brand asset and a brilliant space for personal messaging.

I + my brother's Favorite
Diving Spot — Great Surge
Here!

2-4-77 — Don & Sue at His
Birthday Party - Turned 39

Party animal

Phil·STEphanie·EMILY·J·J·KRISTAL·TAMARA

???·Cennia·Heather·Sophie·Kasey·

Derek·Mike·Valentinos·Talisa·Tyana·Zinnia·???

CONESTOGA!
BEAVERTON, OREGON

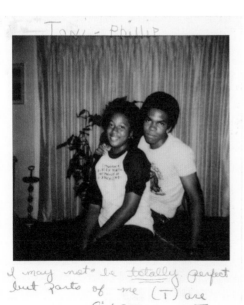

Toni - Phillip

I may not be totally perfect
but parts of me (T) are
EXCELLENT.

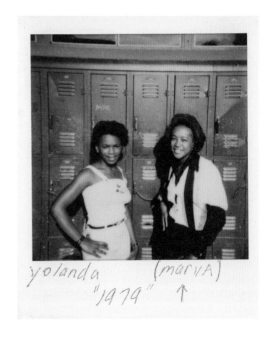

yolanda (marva)
"1979" ↑

 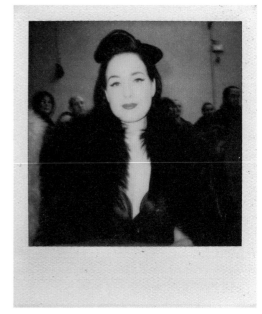

These Polaroids by Antonio Barros were taken at
Paris Fashion Week 2010 with expired Polaroid material.
They feature (left to right) Lanvin creative directors
Lucas Ossendrijver and Alber Elbaz, Dita von Teese at
Alexis Mabille, Kanye West at Louis Vuitton and model
Vlada Roslyakova backstage at Elie Saab.

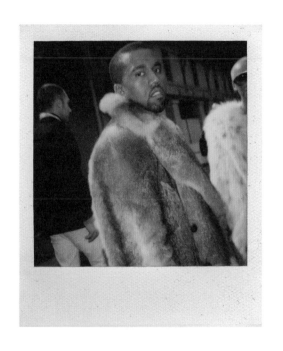

BUSINESS

8 x 10 Polaroid exposed with a portable X-ray bomb-detection unit, showing the contents of an unattended suitcase.

By the late 1970s over a billion Polaroids were shot every year, and for decades a yearly average of over 10 million packs of films were sold. There were over 200 million cameras in circulation around the world.

Surprisingly, all the groups of customers featured so far in this book soon became a minority, in terms of global film consumption. Even if Polaroid cleverly presented their most valuable customers as American families, those artistic amateur photographers, the company would probably have been in much deeper trouble much earlier if it were not for the main business drivers that were the real Polaroid film slaughterhouses.

Over the years, Polaroid convinced many of the world's most interesting areas of business to start using their products, sometimes investing in the development of very specific and sophisticated hardware. A customer who has paid for expensive hardware finds it hard to switch to another new technology when it becomes available. All of these established business partners obediently continued to use Polaroid film even as the dawning of digital photography started to destroy Polaroid's consumer business.

I will just mention three of the most profitable and most interesting business applications built upon the extensive consumption of Polaroid film.

Of all Polaroid's business applications one field had a particular importance to Edwin Land: medicine. Almost from the start, Polaroid spent millions on the development of scientific equipment that could improve all kinds of medical research and therapy.

In the field of diagnostics the advantage of Polaroid film was especially obvious, dramatically speeding up the process as it removed the need to wait for lab technicians to develop and process film. As early as 1951, the first Polaroid-film-based X-Ray machines were introduced, and many more special equipment cameras followed.

One of the best-known diagnostic cameras is the bulky but powerful Macro 5 camera, which produces incredible close-up shots unlike any other. It soon became the favourite documentation tool for eye doctors and dentists, and also for dermatologists, allowing them to precisely document and analyse abnormalities of the skin.

Among the 'last men standing', still guaranteeing massive consumption of Polaroid film until the very end, were eye doctors in Japan. Every male employee in Japan has to go to the eye doctor once a year in order to have the backs of his eyes examined (as an early screening for diseases). Polaroid led the field in this technique of eye fundus photography with a highly expensive camera setup. When you consider that there are around 30 million male employees in Japan you can see why the Japanese Polaroid office was one of the very last to be closed worldwide when the company went bankrupt at the end of 2008.

Sample Polaroids shot with the Macro 5 camera and image grid film, for many years an essential diagnostic tool for dentists, opticians and other medical professionals.

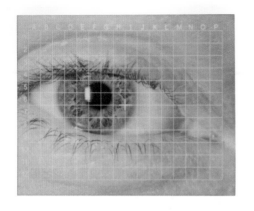

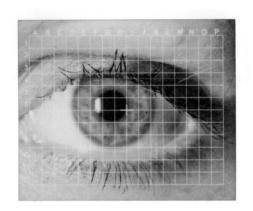

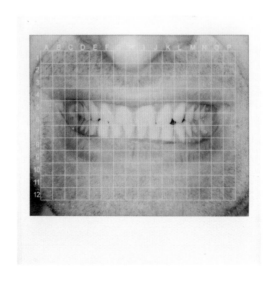

POLICE & INSURANCE

For decades the police were one of Polaroid's best friends. And Polaroid also supported them with the development of specialized equipment to make their job easier. Police forces around the world soon became the biggest customers for 8 x 10-inch film as they started to introduce small portable X-ray devices. These made it possible to analyse very quickly the contents of suspect packages. Imagine a situation where the police find a lonely suitcase at the airport. Instead of closing the terminal and creating the classic disaster of delayed flights, thousands of frustrated customers and high costs, the specialists just take a quick and hazard-free look inside the suitcase by taking an 8 x 10 X-ray polaroid, developing and analysing it on the spot. All of this could be done within ten minutes.

Classic Polaroid cameras were also widely used by police departments, as well as carried in the trunks of basically every insurance agent's car all over the world. Because of their 'incorruptible' character and their pure unalterable originality, Polaroids have always been accepted in court. Countless crime and accident scenes were precisely recorded, and insurance claims were examined using endless damage-documentation Polaroids.

For decades, every police car and insurance agent carried a Polaroid camera to document crime scenes and insurance claims. Up to this day, Polaroid is the most readily accepted photographic evidence in court because of its incorruptibility.

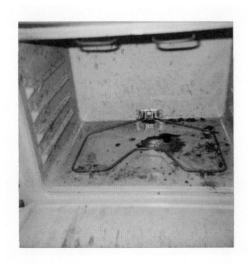

Polaroid also played an important role in the business of passport
and ID production. It is impossible to say how many billions of such
Polaroids have been shot over the years, as the company developed several
generations of special cameras, photo booths and portable mini studios
for just this purpose (and to adjust to the constantly changing quality and
security demands from different countries).

All of these systems worked on the older peel-apart film materials,
in the classic Type 100 format. And again the advantages of Polaroid
systems were astonishing, destroying the competition. One of the biggest
was their stand-alone independence, needing no other resources than
the camera and the film. No delicate chemicals, no other equipment,
no water, no electricity. That is a convincing argument when you are
looking at the task of taking pictures and registering people in remote
areas where none of those things is readily available. This is an advantage
that still exists today, even compared to the most advanced new digital
passport and ID systems. Thousands of analogue passport stations are
still in use.

Unfortunately all Polaroid's other advantages melted away
much faster than anybody expected as the digital sun rose over the
photographic horizon.

A favourite selection
of instant passport
images, from the days
when people were still
allowed to smile in ID
photographs.

3-13-84

1-20-84

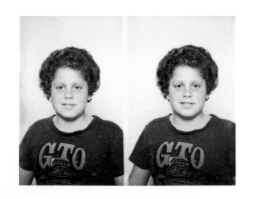

DIGITAL REVOLUTION

Me, fake skyboarding at the 1998 Photokina Polaroid booth, at the launch of the small-format Type 500 camera. So much for the incorruptibility of Polaroids.

The dilemma was obvious and several generations of Polaroid managers could not find a solution to it. The digital revolution and the introduction of digital photography took away the key asset, the essential USP of Polaroid, that it was an instant picture. The famous 'sixty-second excitement' even became a little tragic, compared to the milliseconds it took to display more and more brilliant pictures on increasingly bigger and bigger displays at the back of your camera. And all for absolutely free. As if that were not enough, it also seemed that people simply and immediately lost interest in real pictures they could hold in their hands. 'Kids today don't want hard copy any more', one of the last Polaroid CEOs admitted in frustration at the beginning of this new century, the digital age.

There followed some devastating years, as Polaroid tried to fight this overpowering digital threat with all their resources. Even if there was still a serious amount of cash in the war chest, there was very little left of the brilliance and innovation of former Polaroid strategies. Basically the only idea Polaroid came up with was to continue their strategy of lowering prices by introducing cheaper, lower-quality cameras and cheaper smaller-sized films formats.

This pushed Polaroid even further into the depths of the mass market, a strategy that had its beginning back in the days when Edwin Land had to step down as visionary leader of the company. By 1998 this strategy had already caused an absurd decline in brand value, and in public opinion Polaroid was seen as a producer of plastic cameras given away almost for free. Polaroid even introduced the first disposable instant camera, the 'Popshot', at Photokina 1998, where I had the dubious pleasure of winning a free wild-style Popshot portrait. The camera used the small Type 500 format, already only about half the size of a classic Polaroid picture.

One year later Polaroid proudly introduced the smallest and most childish integral instant film format and film camera ever: the Polaroid i-zone. There are several sad and almost unbelievable stories connected with Polaroid's last analogue stand. To give you an idea of the desperate

despair and the absurd struggle for life Polaroid had to face at that time, I want to share two of them.

The pressure on Polaroid's analogue picture department was so intense in those days that the company decided to launch the i-zone product without having really figured out how to produce these tiny little instant films in serious quantities. Was it a lack of time and resources or simply was it the lack of true belief in the potential of these bonsai Polaroids? As a quick fix they hired volunteers and built a giant darkroom facility in their Scottish factory. For endless hours the workers sat there in red light folding these funny coloured filmstrips by hand, and fitting them into their tiny little black cartridges.

The launch in 1999 was a stunning success and the whole world seemed to be crazy for this new product. Was this finally the end of despair? Looking at the first weeks' sales the management was relieved and after some high-fiving they gave the order to press ahead with the planned i-zone factory at top speed, no matter the cost, resolving the unsustainable situation in Scotland even sooner than they thought possible. In record time, just a few months later, the new factory was ready, but not fast enough to ever produce a single pack of i-zone film as the interest in this toy had also vanished in record time.

And not fast enough to prevent Polaroid from introducing perhaps the most ridiculously awkward camera of all time in the year 2000, the i-zone Digital Combo, the absolute climax of despair. When they announced their concept of developing an instant camera 'combining the best of both worlds of photography, analogue and digital', expectations were high, as customers had long hoped that Polaroid might introduce a splendid digital camera that also had the ability to expose images right away onto Polaroid film. This would be a proud new digital version of the SX-70.

The camera Polaroid finally dared to present affronted even the most devoted Polaroid fans. The Digital Combo basically consisted of two completely separate cameras: the worst Polaroid camera ever produced (the i-zone) glued to a cheap digital camera of at least equally dreadful quality.

The i-zone Digital Combo, one of many desperate attempts from Polaroid to convert or at least combine the magic of their material with the digital age.

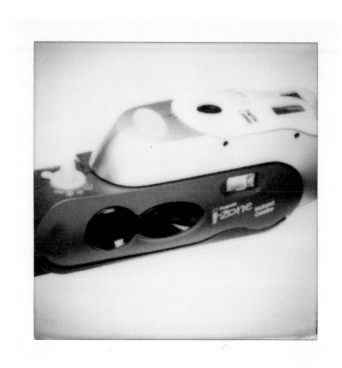

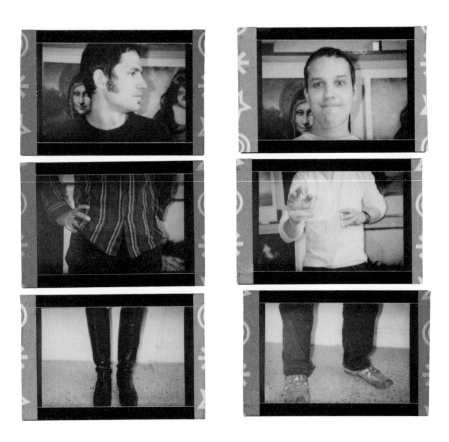

Me and my friends
trying hard to fall in
love with the basically
ridiculous and childish
small-format i-zone film.

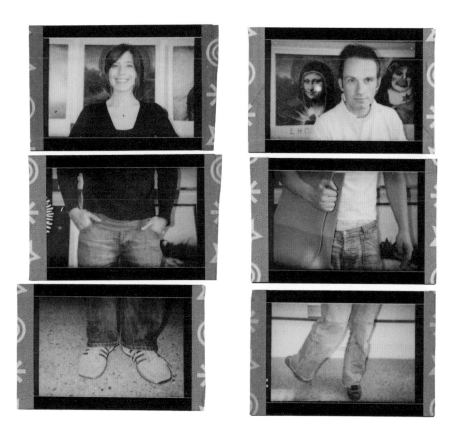

The i-zone disaster was most likely the moment when Polaroid finally wrote off the last remnants of faith in their own core product and analogue instant film seemed to have lost its magic pull forever. On 11 October 2001 the Polaroid management filed for chapter 11 bankruptcy and shortly afterwards the company was sold to Bank One.

In September 2002, World Wide Licenses, a subsidiary of The Character Group PLC, was granted the exclusive rights for three years to manufacture and sell digital cameras under the Polaroid brand for distribution internationally. Soon Polaroid-branded televisions and portable DVD players also appeared on the market.

This was the beginning of maybe the saddest chapter in the Polaroid company's history, characterized by the unscrupulous strategy of using this iconic brand – after all still one of the best-known brands on earth and still positively loaded with the spirit of art, design, innovation and a last glow of magic – to add value to average and arbitrary no-name consumer electronic goods (and then a growing number of products of any imaginable kind) mainly produced in Asia.

To start with this strategy worked out very well in the US market where customers were willing to pay a lot more for digital gadgets branded with the Polaroid rainbow colours and logo than for the very same camera next to it bearing a name they could not even pronounce. As a matter of fact, Tom Petters, an American-dream-come-true salesman and hyper-entrepreneur, bought Polaroid for $426m in January 2005.

Looking at his new property with its large portfolio of factories spread out all over the world producing all the complex components of analogue instant films, and taking a quick look at the downward curve of film sales, Petters would have asked his management team in one of their first meetings for an optimistic yet honest estimate of when this curve was going to hit the ground. The answer was ten years, the year 2015.

What happened next was not really surprising but nevertheless it was one of Polaroid's best-kept secrets. Even though Tom Petters never tried to understand the real magic of Polaroid, he did not dare to question openly one of America's most iconic products. Unofficially, he ordered all instant film factories to produce enough materials to meet the estimated demand for Polaroid film consumption over the next decade and then he closed down all of them one by one and sold the real estate. A few months after he purchased Polaroid, he had re-financed most of his investments.

Only four factories survived this clearance sale, located in Mexico, Scotland, Waltham in Massachusetts and Enschede in the Netherlands, and even these were drastically downsized. These factories housed the

last assembly machines needed to manufacture final film products from pre-produced components stored in warehouses around the world. The factory in Enschede produced all the integral film products, in Scotland they produced the small Type 80 peel-apart film, in Mexico the larger Type 100 and 4 x 5-inch peel-apart films and Waltham was home to the delicate large-format 8 x 10 and 20 x 24 film production.

I knew nothing of these scary new global strategies, as I nervously prepared for my first real meeting with a high-level Polaroid manager called Markus Mahla in Frankfurt at the beginning of 2005. Only ten months after my very first, very reddish Polaroid, I was sure that it was not because of my astonishingly handsome model Hentschelero, nor simple craziness on my part, but I had fallen deeply in love with this material at first sight.

I was bored and frustrated by the way that Lomography had decided to fight the digital threat with cheap plastic cameras and highly questionable profit optimization processes. There was something different going on. Something out there, that woke up all my scientifically trained senses as a spider eye specialist and set off several all-analogue alarm clocks in my curious mind though so far nobody else seemed to be really interested. But what was it?

LAST GLOW OF MAGIC

It still was out there, Polaroid's magic spell. And even if it was just the faintest, fragile flickering glow, it was enough to put a spark in my heart and to set me searching for the source and the secrets, a journey that is still going on as I write these words. I was willing to give much more than just my attention: I dived in up to my neck. At the start I was alone but traces of Polaroid seemed to be surprisingly everywhere.

Adidas had just launched a big campaign for their Adidas Original line using Polaroids and Polaroid cameras. Their flagship store in Berlin Mitte looked almost like a Polaroid museum. Not much later Diesel, the jeans fashion brand, hired the acclaimed photographer Terry Richardson who shot some fantastic Polaroids, spicing up their campaign with the sparkling erotic vibes that only real Polaroids can transmit.

At the same time more and more agencies started to fake Polaroids by putting a white frame (preferably with added dirt or fingerprints) around their boring all-too-clean digital images. It was almost impossible to open a magazine without finding these bad fakes all over the pages.

All of this contrasted with the way that consumers still seemed hardly aware of the existence of Polaroid, getting rid of their apparently worthless instant cameras to buy a new digital model. They were almost encouraged to do this by Polaroid itself as distribution was scaled down so dramatically that it soon became expensive and nearly impossible to buy films, especially if you were living outside a big city.

The cultural omnipresence of Polaroid even in these adverse market conditions was a very clear sign to me that I wasn't the only one to sense the mystic spell of something declared obsolete. It was at least as surprising to learn that another iconic analogue product, the classic vinyl record, was repelling all digital attacks and had even initiated a glorious worldwide comeback tour. I had everything I needed to quit my job and become Polaroid's new evangelist. I set myself what I thought would be the easy first task of using this spark in my heart to set Polaroid management on fire, burn down all their digitally induced reservations, convert them back to the true analogue faith and launch together the biggest comeback ever in the world of photography.

It was a little bit more difficult than that. It turned out that Polaroid management were not desperately waiting for me and my sermon. It took more than eight hours and a large selection of my most cunning tricks to finally get on the famous paddle steamer Polaroid always rented during Photokina, Europe's biggest photography fair.

Eight hours for a polite eighty-second chat with Markus Mahla and Michael Hefner, who according to their business cards had an important role in Polaroid's marketing and business development. I was informed that Polaroid was in the middle of a global internal restructuring, repositioning itself as the future of photography, and therefore they did not have time to listen to external advice (especially when offered by an obviously bewildered biologist from Vienna wearing a small ponytail). Bewildered but very stubborn!

In early 2005, approximately four months and forty phone calls later, Markus gave up and invited me to visit the European HQ in Offenbach near Frankfurt. Exactly forty minutes before this meeting I received a message from Markus that 'due to some unexpected developments of the highest urgency' he had to fly to the US but Mr Hefner would be there to listen to my lecture.

It must have been almost exactly the moment that I nervously opened my laptop and started my presentation about the comeback of analogue instant photography that the new owner of Polaroid, Tom Petters, was outlining the digital future of Polaroid to Markus Mahla, informing top management of his decision to phase out the instant business. That is a crazy coincidence that really has a nice feel to it, especially as I never did believe in coincidences anyhow.

In contrast, Michael's reaction to my passionate forty-five minute glorification of Polaroid's magic potential did not feel nice at all. 'Well, Florian,' he said slowly, 'this is really one of the best presentations about Polaroid's brand values I have ever seen. Unfortunately it is at least three years too late. As you have heard Markus is meeting the new owner of Polaroid right now. Even without knowing all the details, it is certain that our focus from now on will be on digital to the exclusion of all else.' And now it started to feel a little crazy as he continued: 'But if you really believe in the potential of this analogue material we continue to produce, even without any budget for promotion or repositioning – if you really believe in this potential comeback and the discovery of new customers and markets – why not take on this project yourself? You seem to have a strong background as a salesman from Lomography.'

One of many exhausting meetings with high-ranking Polaroid managers Markus Mahla and Michael Hefner, wrangling over the last legal details of our professional sales agreement.

Looking at my baffled face he continued to outline all the advantages of becoming a Polaroid retailer and the incredible support he was willing to give me. He told me that it was usually a complicated process to be listed as a Polaroid partner, but because of my expertise and my obvious passion, he could fast-track this for me. The only small thing I had to do was to sign a contract that guaranteed Polaroid a minimum of €180,000 for the first year.

'Just a moment!' I dared to interrupt, '€180,000 worth of Polaroid film without having sold a single pack of it before?' 'Well,' Michael replied, 'looking at the numbers in your presentation and naturally believing that these numbers are based on reality and are not just faked, a first order of €180,000 (around 25,000 packs of film) shouldn't last you more than just a few weeks. Or do you have any doubts about your own assumptions?'

Amazingly, I did not have any doubts and on my way back home I called the only two people I had convinced so far: my wife Anna and my crazy partner Lex 'Eduardo' Webmeister. I call him crazy because this genius programming scientist has been at my side in good as well as bad times on a splendid selection of wild projects. Having left Lomography with me, it took Lex just a few seconds to accept this challenge and to start gathering his share of the €180,000. It took more than a few seconds to get the green light from Anna, but at the end of the day I was able to borrow the rest of the money from my family and some close friends and I founded a company with Lex. A few days later we signed our first purchase order with Polaroid, moved into a small office sublet from a friend's company and started to think about the best way to turn our good-looking keynote presentation into rock-hard profitable reality.

We figured that it would take us about six months to develop all the clever structures we needed to promote and sell the film in a suitably revolutionary style. And then it would be time to trigger the first film shipment from Polaroid to our yet-to-be-defined new warehouse with its embedded logistics centre. Everything seemed to be perfectly under control.

Unfortunately we hadn't read the small print of our purchase order, which committed us to the immediate delivery of a big portion of the film we had agreed to buy. So it was on our third day in the office, as we were drawing our first diagrams on our first pack of A4 paper, that the doorbell rang and we discovered a giant Polaroid truck in the street, stuffed with more than 10,000 packs of film. As we desperately tried to squeeze it all into our small office the sunny day turned into night with us still piling up boxes.

The truck that changed the lives of me and my business partner Lex, and the piles of Polaroid films, stuffing our 20 m² office with more than 10,000 packs.

From that point on we had a pressing reason to speed up the search for the new customers who so far only existed in our imagination and on pages 23 and 24 of my presentation. But how to find them, in both real and virtual life? How to connect with them?

At the same time, we also had to refine all these positive feelings and sparks of magic down to some clear product descriptions and sales drivers faster than we had ever planned. In the threatening shade of 10,000 Polaroid film packs we quickly decided to launch two separate websites.

Firstly, a global 'Polaroid only' online picture-sharing platform called Polanoid. Polanoid.net would become the new home for all the world's Polaroid pictures and a cosy VIP (Very Intriguing Polaroids) lounge for all the photographers who shared our passion for this iconic material. A perfect place to meet, connect and get to know each other, as well as an ever-expanding online gallery presenting amazing Polaroids from all over the planet.

In parallel we developed and programmed the first online shop for Polaroid film and cameras. It is hard to imagine in today's digital world, but ten years ago unsaleable.com was the very best (and very only) place on the internet to buy analogue Polaroid and even more importantly it was the place to learn about different films and formats and their compatibility.

The stockpile shock treatment really worked and in June 2005 we launched our online shop, followed by polanoid.net a few weeks later. With these communication and analysis channels in place we were finally ready to flesh out our theories with facts (and our empty pockets with money!). We were collecting all the glowing puzzle stones, putting them together one by one until we had a clear picture of what this new Polaroid magic was all about.

Incorruptible proof that Lex (a.k.a. Webmeister) and I did launch the first online shop for Polaroid materials at the beginning of 2005.

PART 2
RE-DISCOVERY

THE FLIP

The famous, almost illegible, 'flip' theory and its inventor Professor Heine from Berlin.

With most riddles, the solution appears to be totally logical as soon as you have found it. This is exactly how I felt one day in 2011 when my friend Achim Heine 'The Professor' drew some lines on a flip chart in his office in Berlin. Even if Achim's glorious handwriting was illegible as usual, the simple drawing perfectly conveyed the essence of Polaroid's rediscovered magic. This 'flip', as I have called it since that day, brought together all the hundreds of puzzle stones that I had eagerly collected for years before into one clear message.

Digital, the cruel and relentless gravedigger for everything analogue, suddenly turned out to be a wonderful midwife for the rebirth of Polaroid.

Ever since digital photography entered the mass market, the world started to rediscover Polaroids from a completely new, digitally impacted, point of view. The unique characteristics of a classic Polaroid picture suddenly seemed to have a new, stronger and more truthful meaning.

In Achim's drawing this happens when the blue line (standing for instant photography) finally crosses the green line (standing for all the other kinds of photography). At that point, Polaroid's essential advantage – being visible faster than any other kind of photography – has vanished. But contrary to expectations, this crossing point was not the end of the (blue) line, but the beginning of a new age where instant photography is slower than the new state-of-the-art photography, but has a new identity that needed exactly this digital 'flip' to reveal itself.

I am not talking about new and improved characteristics (as you can see, the blue line is as flat as a mummy's cardiogram). I am talking about a new point of view that suddenly adds new flavours, values and facets to Edwin Land's iconic invention.

I think the biggest problem of the digital age, and not just for photography, is the loss of originals. When digital technologies started to conquer the world all the experts said that as soon as the quality of the new digital tools surpassed analogue benchmarks then analogue would disappear within months.

It turned out that this assumption was completely wrong. The biggest challenge for digital is not about quality but the fact that digital does not create anything real and valuable just codes and numbers. Digital photography does not provide you with real pictures; no intimate instant originals are slowly developing in your hand.

Most of what is created digitally never makes it into reality and ends up on hard drives or external storage devices, many of which may not be accessible any more because of rapidly changing standards. All of the industry's attempts to change this have failed. And they really tried, believe me, because their own new digital photo business was built on the assumption that people would start printing their images. More and more images were taken; fewer and fewer images were printed. The classic family album, documenting decades of our society, started to vanish.

Andreas Schelke described this in his essay about the oblivion of digital pictures: 'Photos which fail to find their analogue materialized expression disappear from the social presence just like the spoken but not documented word of earlier generations. With this dramatic loss of memory, the digital photo and the spoken language are similar – easily evaporating in the moment of communication between people – nothing more.'

When you understand this, it is painful to think about the amount of effort spent over the last few years converting valuable analogue properties like books, photographs and music into digital files in order to preserve them for eternity. The exact opposite is urgently needed to avoid the dramatic and irreversible perishability of our digital presence. The real record of our time is and will be analogue.

Soon it became clear to me that Polaroid's instant originality had a deeper impact on people who grew up in the digital age, who had never touched their images before, but just looked at them on their devices, always covered by a thin layer of glass. I only had to look at my own children, who loved their Polaroids from the very first moment, without any background nostalgia. Suddenly they had something in their hands, something to touch, collect, play with, shake (yes, this was allowed from now on, as the guys from OutKast changed the rules with 'Hey Ya!') and

My favourite Escher-style Polaroid in a Polaroid in a Polaroid in a Polaroid.

even something to smell. Something to stick on their walls or hide in their diaries. The impact on them was even stronger than my own first experiences with Polaroid, because it was their first encounter with a real analogue picture. A picture not just visible to their eyes, like the ones they were used to capturing on a daily basis, but something to be discovered with all five senses.

Of course I was not the only one to discover this and before long the digital industry tried to react. It hardly needs to be said that every attempt to fake or transfer the sexiness of analogue originality into the two-dimensional sensory world of digital has been a failure. Even in the case of a big global player like Apple trying to compensate for the reality deficit of music files by adding old vinyl cover artwork to iTunes. Or the extensive use of fake Polaroid frames around digital pictures. Or the super-sophisticated 'turning real pages feature' for your touch-screen e-readers. At the end of the day these design strategies only increased the desire for real originals, as proven by the rapidly growing sales of good old vinyl records and even the fact that you are holding a real book in your hand made out of real paper.

Even one of the biggest disadvantages of high-quality originals, their high production costs, flipped over easily and turned into another positive side effect for customers. Suddenly they cared again about every single picture. No wonder, after paying $20 for a 10-pack of old Polaroid film that was harder and harder to get. At first glance this is a serious investment just to take a very limited number of pictures. But after you have taken millions of digital pictures of averagely exciting moments for absolutely free and then never really looked at them again, it is quite something to carefully frame a picture and to think twice before pushing the button. With one click the value of photography was back and it felt very good to care about every single Polaroid slowly developing in your hands.

Webmeister and myself on our first Polaroid magic research trip to London, developing our very first Polaroid original project.

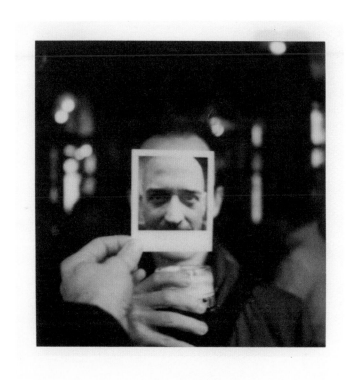

NEW QUALITY

Test shot with super-rare vintage 778 film material, carefully matured in a forgotten warehouse for over twelve years.

None of the studies comparing the quality of analogue to digital images even looked at Polaroids, because with their 'unpredictable' and 'questionable' quality they seemed unqualified to take part.

This seriously underestimates Polaroid's real capabilities and its true soul. Digital cameras became ubiquitous at the end of the 1990s and soon their general quality reached analogue levels. People slowly started to experience not only the advantages but also the disadvantages of this new way of taking pictures. It became obvious by about 2004 that not only were people starting to miss real images but even more surprisingly they were starting to get bored and almost a little scared of the sterile perfection and predictable results of using near-perfect hardware.

When any possible mistake is erased before you can make it, people stop feeling like artists and photographers. The devices basically take control: auto-focus, auto-exposure, auto-framing, auto-flash . . . cameras even started to recognize faces and to automatically trigger a shot as soon as somebody was smiling. As a result, digital pictures became interchangeable, with their very clean look defined by the camera rather than the photographer's own creativity.

Suddenly, the deeply unpredictable chemical adventure that shooting a Polaroid has always been started to attract digital photographers who were searching for challenges and ways to create their own moods. This rediscovery of the attraction of analogue imperfection was perfectly documented by the stunning success of Instagram, a very cool iPhone app that converted your boring interchangeable images into valuable-looking fake analogue pictures, to be simply and proudly shared with the world. Millions of dollars had been spent on reaching perfect-quality digital images and now the whole world went crazy for an easy way to mess these images up again. The unique analogue quality of Polaroids, closer to a light painting than to classic photography, was suddenly the hottest look in this digital world. With the warm certainty that even the best digital fake cannot come close to the beauty of analogue reality, I was delighted to see Instagram's success, silently waiting for their users to start digging deeper, searching for the real stuff.

In the meantime Webmeister and I were also digging deeper in our search for the secrets and sources of Polaroid's magic. But one of our greatest discoveries happened by chance.

It all started when we visited the legendary Alex Cad in his wonderland of analogue camera treasures in Croydon, south of London. We wanted to hunt down some rare Polaroid cameras, but our dream was also to also learn from Mr Cad, as for five decades he has been without any doubt one of world's biggest camera dealers and for us the uncrowned king of analogue photography. Mr Cad was super-nice and supportive and not only sold us some cameras but also a whole pallet of Polaroid film. Because we had just started our Polaroid business he kindly offered us an irresistibly cheap special as some sort of 'newcomer welcome deal' and even drove us back to the train station in his crazy metallic blue Japanese sports car after the deal was sealed.

Deeply impressed by his warm welcome we shipped the pallet to Vienna. Yes of course we already had enough film, and the piles at our office had not really started to melt yet, but who could possibly resist this incredible special offer from the charming Mr Cad?

It took just sixty seconds to understand the true nature of the 'newcomer deal' when we stared at the first test shots with the films that had just arrived from London. The results looked like totally burned chemistry and you were lucky to have more than half of each picture developing. 'Of course the results are special,' Mr Cad explained to us politely on the phone, still very supportive and charming. 'These films expired about four years ago. I thought this must have been clear to you from the special price.'

Well this was the first we ever heard about an expiration date and the first time we discovered the wild results of more-or-less carefully 'matured' film. Newcomer lesson number one was learned the hard way from our charming teacher Mr Cad.

What to do now? Our first reaction was to simply accept our mistake and to trash the film. But we soon found out that because of the batteries included in every Polaroid integral film pack, disposing of them would have added even more costs to this already financially disastrous 'Newcomer Project'.

The famous Mr Cad from London, shot on an even more impressive vintage film material (unfortunately not very carefully matured).

My favourite Polaroids
shot on Mr Cad's iconic
'fire expired' material.
Surprisingly, this was
the best-selling Polaroid
film we ever offered,
because of its highly
unpredictable nature.

So there was only one direction left to go: full steam ahead. We launched our first global email campaign, proudly introducing this crazy film under the name 'Fire Expired' with a wonderful gallery of pictures 'on fire' and a description of how lucky we had been to discover this unique stock, carefully aged in the UK. Of course it was almost twice as expensive as boring ordinary Polaroid film.

The whole stock sold out in less than four days, marking the beginning of a series of successful 'special quality' expired film projects, which were among the main drivers of our growing business. We celebrated carefully seasoned film, tracked down all over the planet and presented with all our passion and love. The worst-quality film according to standard definitions, material that was many years beyond its sell-by date, suddenly became the most in-demand, with exactly one trusted online dealer.

At the same time as we searched the world for out-of-date films in old warehouses, police departments, hospitals and garages, Polaroid still carried on with their crazy attempts to reach quality benchmarks. Benchmarks that were defined a long time ago, setting standards for colour tones, saturation, development time and more besides. During my first visit to Enschede in 2007, invited as the fastest- (in fact the only) growing retailer in Europe, I saw the extent of this tragedy for myself. I watched a whole team of dedicated and highly experienced people fighting for perfect-quality film, trying to control its behaviour. 'Why', I asked them, 'do you spend so much time trying to squeeze the film into standards, when we all know that every film pack reacts differently depending on the temperature, the humidity and even the different wavelengths of light from day to day? Something you will be never able to control, as you have customers all over the world using this film in different climates, at different times, in different seasons?'

Standards are needed to keep the glory of Polaroid's brand alive, the factory managers politely informed me (the very same managers who without hesitation started to put the Polaroid brand on shoddy televisions and even tennis socks, by the way). Not a single film pack that does not match the latest approved quality standards from US headquarters was allowed to leave the factory.

I learnt a few hours later how desperately serious they were when I discovered a giant room stacked with pallets of film packs, marked with red crosses. 'These are the films that failed the test', my factory tour guide informed me. 'They are waiting for our big scrap machine. You cannot imagine how many films and cameras have been scrapped

here. Sometimes this makes me sad, as we put so much effort in producing them.'

I could not believe it. I was desperately searching for expired films as they were clearly the most in-demand Polaroid material out there. Precisely because of these unpredictable chemical adventures, a new generation of customers had started to rediscover and fall deeply in love with Polaroid. And here at the factory thousands of film packs with the highest creative potential and undiscovered beauty were destroyed on a daily basis!

I convinced the guide to give me one of what they called a 'wrong colour balance pack' and right away I started to shoot some test pictures. All of them turned out beautifully with a tasty touch of orange. I simply had to save this amazing film and right away offered to purchase the whole stack for the normal purchase price and to promote this film as 'Orange Tone Special Edition'. I tried to explain that customers would love this film, and that the campaign would probably even add value to their brand and certainly not cause any damage.

The general manager of the factory did not look convinced but at last he agreed to call Polaroid headquarters in the US. After some anxious minutes he came back to me with a second newcomer lesson for Polaroid retailers: 'You can't have everything.'

Well, I have never been ready to accept this lesson, especially when something feels so desperately wrong and out of step with reality. That day at the factory I promised myself I would fight for this material and its true nature the very best I could. To my way of understanding, the world was finally ready to grasp the real soul of Polaroid. After all those years of fussing about quality, the digital flip suddenly enabled people to sense an incredible new energy when looking at these small pictures which seemed to have a will of their own, never fully controllable but always true and real.

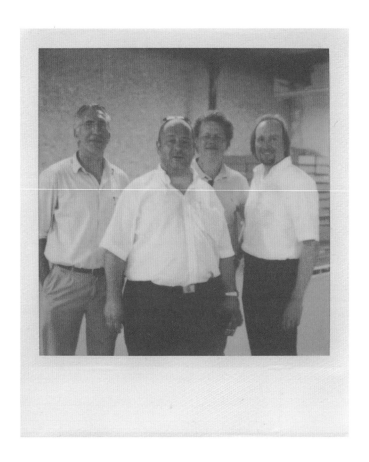

These are the only two images I was allowed to shoot with the 'wrong colour balance' packs I discovered in the Polaroid factory, scrapped only minutes after my visit.

A few years later I had to learn the importance of understanding, accepting and respecting the true nature of things in the hardest way. My youngest son Valentin was always 'lazy' and did not seem to be interested in activity at all. He learned to walk very late and drove the whole family crazy because every game, every exercise, every sport always ended in a shouting match because not even the most sophisticated motivation techniques, pleas or sweets could convince him to change his attitude and behaviour. I remember yelling at him at the top of a mountain as he completely refused to move an inch downhill, after we had kitted him out with a new skiing outfit and a four-day ski pass.

At the age of three, we finally discovered that his 'laziness' was caused by a rare form of muscle disorder. Shock and deep sorrow combined with endless helplessness as there is no cure for this progressive disease. Our relationship with Valentin totally flipped, as finally we could accept him the way he really was and he himself could finally stop struggling to meet our false expectations and could act according to his true nature and his abilities, without creating all this frustration and disappointment around him.

Since then I have tried even harder to understand the true nature of challenges, and I try not to take fast decisions based only on superficial expectations and standards set by society or – even worse – following tradition.

If only I could spread the magic of the rediscovered true nature of Polaroid to everyone out there who is searching for authenticity in this increasingly uniform and globalized world! How good it was to find out that I was not alone on this mission. Once again, artists were at the front of a long and fast-growing line of people ready to jump into a new chapter of Polaroid adventures.

Valentin on one of his rare attempts to fall in love with sport.

ART

(Left) Spittocco.

Despite the questionable financial success of our gallery project Polanoir, I still believe that Polaroids should be among the most valuable treasures on the art market, not only because of their magic but because they are the only photographs that are not reprints but originals. Here are some favourite images from artists who started to discover Polaroid at about the same time that I did. (Left) Spittocco.

A new generation of artists were discovering Polaroid material. This time they were not searching for perfection or using Polaroids for fast test shots. This time it was all about the chemical adventures, reinterpreted in a digital world. Painting with light, never in control of the medium, diving deep into the real soul of Polaroid. I can hardly describe how good it felt for me to look at these images and to sense that for the very first time Polaroid was finally accepted the way it has always been.

For me, one of the leading roles in this new movement was taken by Stefanie Schneider, a German photographer and friend who has my true respect and admiration for starting an intense relationship with expired Polaroid film. She inhaled and almost melted into this unpredictable material, creating a whole world painted in its warm pastel colours and flaring artefacts. This world is centred on the desert town of Palm Springs and even now, many years after she started on her road trip, her images have not lost any of their urgency. Her worldwide success was a big support on my mission to fight against the fading of Polaroid's magic.

Annika von Taube brilliantly described Schneider's work in her article 'Memory Overexposed':

Photographer Stefanie Schneider takes our memories into the light. Bleached out colours slyly seduce, overexposures disguise, and blurred outlines arouse the impression that these Polaroid images have been uncovered in a dusty photo album on the attic floor – our own . . . The pictures retrieve memories – of hot sand under your feet, of untroubled happy moments of doing nothing at all . . . Memory is imperfect. It has gaps and tears. It's exactly the same for the film material used for these photos, which appear so immediate but are actually carefully staged. Polaroid film is used and its expiration date is so far gone that chemical reactions bring out visible damage to the material in its printing. Thus the Polaroid film's ageing progress and its expiration go from being the epitome of holding onto fleeting moments to an image of our memory. It's not a reference to that which we remember, but rather to how we remember – it becomes an illumination of memory.

Stefanie Schneider.

Filippo Centenari was another young artist who shaped my understanding of Polaroid's true nature in those days. Shortly after we launched the online shop he called me with a simple question: 'Hey Doc, these SX-70 films you are offering online, are they manipulable?' 'Sorry, sir,' I replied, 'I don't understand. What exactly was your question?' Even after his third attempt to pronounce the world 'manipulable', he could not make me understand. This book was not yet written and I knew nothing at the time about the wonderful manipulation technique discovered and performed by artists like Lucas Samaras many years before. But Filippo did not give up and explained this technique to me. I was amazed and right away took some test shots in the office and started to manipulate them the way Filippo had taught me. The disappointing results did not really tell me whether these films could be manipulated or not. So I sent Filippo some test packs to find out. The images he posted shortly after took our breath away. Yes, these films could be manipulated if you knew how to treat them right and were ready to experiment and learn.

As our business took off, we found ourselves having more and more conversations with established art photographers, comparing the films we offered with the films from back in the glory days. There was also exponentially growing interest from young art photographers all over the world whom we started to support as much as possible. While we were far from anything like a proper restart of the legendary Polaroid Collections, we nevertheless could not help but initiate a small Polaroid-only gallery project called Polanoir.

We soon found out that the art and gallery world was too complicated for us, but it was a pleasure to organize and host several exhibitions, publish several Polanoir catalogues with outstanding artists and even to sell a reasonable number of Polanoir Edition prints worldwide. Perhaps it was a mistake to produce large prints from the originals, even though these were strictly limited runs. Looking back, it would have been a more consistent message to just offer the unique original photos, as these have always been the true treasures of instant photography.

My first attempt at the mysterious technique of manipulation (left) next to the work of manipulation expert and Polanoir artist Filippo Centenari (right).

Grant Hamilton,
Lars Blumen.

Norah Goldenbogen.

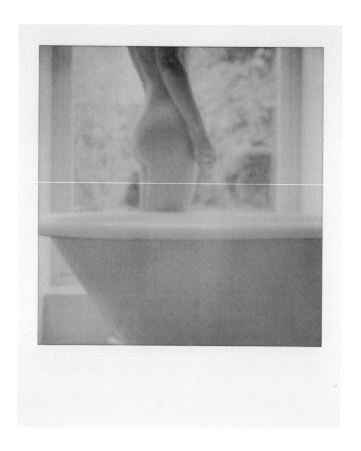

PORN

A photo love story from the erotic Polaroid-only magazine *Tickl*, representing the rediscovery of Polaroid's warm soft tones in a world of crystal-sharp close-ups of gigantic body parts.

Even if Polanoir did not manage to change the world of art collecting, it was a very important experience for us. One of the things we learned from the sales of our prints was that Polaroid's caressingly warm erotic content still created the most interest, as it probably always had done.

Caressingly warm erotic content – what does that mean?

The ruthless precision of digital photography, the crazy search for harder and more extreme stimuli, and the newly discovered exhibitionism of the internet has led to an overload of private pornographic pictures. Suddenly everyone seems eager to share close-ups of body parts that are not usually visible in public, not only for moral but even for aesthetic reasons.

What has happened to the intimate, tingling world of private erotic photography initiated by Polaroid in 1948? As digital images have increased in number and detail, they have lost one important element that Polaroids always added to erotic photography: a deeply romantic and intimate touch that even the most explicit Polaroids always have. This touch is caused by the warm, reddish reaction of the photo chemistry to low light conditions, and the lower contrast that affectionately softens most Polaroids.

Compared to the zillions of super-crisp digital porn pictures floating round the web, the magic of erotic Polaroids started to shine brighter and warmer than ever before: a fact that simply needed to be celebrated. One of the young Polanoir artists, the incredible Carmen de Vos, took on the challenge of directing this delicate project: a magazine called *Tickl* stuffed with nothing less than a careful selection of the sexiest Polaroids and stories from all round the world. Over the years Carmen and her team of volunteers published four outstandingly horny magazines, celebrating the most delicious and delicate form of pornographic storytelling.

 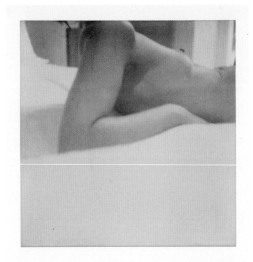

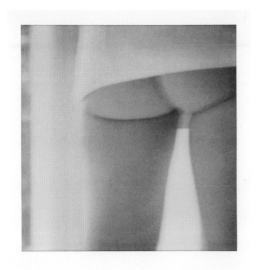 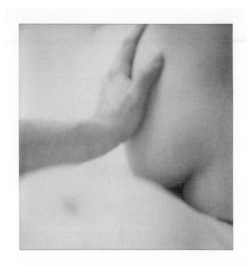

SHARING

In the digital age, keeping hold of your precious moments and controlling how they are shared is a bigger issue than ever. In former times this was mainly a concern for people living under repressive regimes. East Germany, China and the Soviet Union were all huge markets for Polaroid, even if it was officially banned in most of them.

Today the regimes have changed but young people nevertheless have to experience on a daily basis how pictures of their private lives, some of them taken without consent, are shared with the world, completely out of their control. It is not just a retro trend that Polaroid cameras have again become the most in-demand party tools. Young people simply experience how good it feels to know for sure that these images you shoot during the evening will stay safely in your pocket.

Even the unmistakeable sound every Polaroid camera makes when taking a picture finally has a purpose, as it dramatically reduces the chance that somebody can take a picture without it being noticed. But Polaroids offer more than just privacy and control. Sharing these little white framed originals also reintroduces a new level of value. Compared to a low-res jpeg attached to an email, or shared on WhatsApp, Instagram, Facebook, how much better a real Polaroid original shared in real life feels!

Slowly we started to relax, after all the stress at the beginning, as it became clearer that my sense of this new kind of Polaroid magic was not just in my head but also felt by many others. The intensity of our customers' reactions surpassed our wildest expectations.

Instead of killing instant photography by introducing much faster, cheaper and more brilliant pictures, the invention of digital photography had added new super powers to Polaroids. Digging deeper and deeper over our first years as Polaroid psychotherapists, we did not find among our customers many of the traces of nostalgia mixed with sympathy that we might have expected, but rather an incredible curiosity.

'Expensive' had turned into 'valuable'. 'Bad quality' had turned into 'rich in characteristics'. 'Ridiculously unpredictable' had turned into 'excitingly challenging'. Best of all was the simple and pure feeling of just holding your picture in your hand immediately.

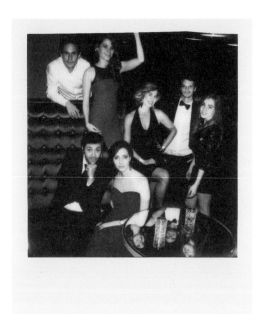

Documenting the
surprising rediscovery
of antique Polaroid
cameras as must-have
party items.

NEW CUSTOMERS

A new generation
Polaroid customer
shoots a self portait
Andy-Warhol-style.

Who were these new young customers? Starting this business essentially for me and my friends, swapping theories with my friends and family, our focus was on customers who like us were in their thirties, carrying some primary infection of the Polaroid virus from their childhood that could now be re-activated. The events we hosted did match these expectations to start with and we were among the youngest at our Polanoir exhibition openings.

But very soon this changed and the digital generation surprisingly took over. Going to a shop opening in 2011 felt exactly like crashing my seventeen-year-old daughter's pyjama party! After the initial shock, I convinced myself that this was the very best that could happen and 'the old boring guys' celebrated this in a cosy bar with some wine of approximately the same age as ourselves.

I will never forget the sight of young kids carefully turning their first Polaroid over in their hands, looking for a small integrated bluetooth or micro-USB connector or at least a wireless indicator that would explain the appearance of an image within the white frame.

The Polaroid world was changing rapidly and with the help of our two channels – the online shop and our fast-growing Polaroid-sharing platform – we learned more every day. What we learned was very promising for our whole project, and the huge piles of Polaroid film were melting faster and faster. We moved into our own space in 2006, a crazy combination of office, shop and most importantly a gigantic old wine cellar, perfect for storing all the rare film treasures we were still furiously collecting.

The Polaroid company itself was inadvertently our biggest supporter as they had absolutely no interest in their own analogue customers. Not only because of their new focus on digital, but because they had completely handed over any direct customer contact to the big retailers. It seems to me that this is one of the biggest threats for any global company, but especially one that intends to be innovative, to sense the customers' needs before the customers themselves even know about them. Not knowing your customers makes this task, formerly the absolute strength of the company, very hard.

Anyhow, it was clearly to our benefit that Polaroid had no understanding and even less interest in their remaining analogue customers. They started offering me the last production runs of all their special niche market materials as one by one they were discontinued. And even if they continued to scrap all the film that did not meet their absurd quality standards during production, they at least started to connect me with their traditional dealer network so I could gain better access to warehouses with piles of expired Polaroid film stock.

We really had a great time and a very good relationship with Polaroid in those days. So I was invited to play with the very first patches of the brand new Zink paper that they were planning to introduce. Zink stands for Zero Ink and it can be described as a kind of paper that contains sophisticated colour molecules, activated by heat. The first steps towards this super-clever product dated back to Edwin Land and since then many millions had been spent turning the concept into reality. During Polaroid's bankruptcy, the Zink project was separated off in a management buyout. Now the strategy was to somehow re-connect the new digital business to the paper, which was ready to enter the market, by introducing a portable Zink printer.

I liked the idea of playing with a paper that originated as one of Edwin Land's inventions and I invited fifty members of our Polanoid.net network to start a crazy series of experiments to explore the capabilities of the medium, even without a printer to hand. Who needs hardware, when it is all about unpredictable chemical reactions?

The results were fascinating, and I started to feel some sympathy for these little prints, no matter that they were heavily criticized in the digital world. These papers had real creative potential when entering our crazy analogue test labs. For that reason, these images (and the leaflet on page 177) are the only ones in the book that are not Polaroids.

I proudly prepared a portfolio of the very best Zink experiments from all over the world. Paintings made with heated tools, with hot liquids, crazy chemicals, high pressure, microwaving ... maybe this material could even be the long-awaited bridge between digital and analogue? I was very much looking forward to meeting with Polaroid. Finally I had some good news for them after all our disagreements over their digital products and strategy and their ignorance of the true magic of Polaroid.

First 'Zero Ink' paper experiments researching the capabilities of the new 'magic' material, introduced by Polaroid in 2008 as a replacement for their instant films.

I have to admit that I was a little nervous as for the first time I was personally invited to meet the most important US executives, who had flown over to Germany to present the Zink printer as well as their strategy for the new age of Polaroid instant photography.

Nervousness soon turned into bewilderment as I listened to the keynote address from Polaroid's Chief Marketing officer: 'Gentlemen, before I show you the long awaited Zink printer, I want to inform you of a very important fact: none of us in this room will probably buy the product, as our sophisticated market research, commissioned from one of the best agencies in the US, clearly shows that it will principally appeal to children between the ages of seven and fourteen. Therefore we have decided to call this product "PoGo", adding a playful touch, and as soon as possible we plan to add pink, purple and orange versions.'

As he went on, my bewilderment turned into anger and frustration. How dare he treat this amazing product, the last little legacy of Edwin Land's spirit, the very last chance to finally re-establish Polaroid as the world's leading brand of instant photography, this creative treasure . . . how dare he treat it like a kid's toy? I knew I had to behave myself. I was just a guest here, and basically all of this was not really my business.

Could it get any worse? We leapt that hurdle when I was introduced on stage as 'Doctor Kaps, from beautiful Vienna. Kind enough to still take care of Polaroid's analogue customers who by now must be too old and senile to jump on the digital train or even make their way to the shops and buy themselves a simple digital Polaroid. Thank you Doc for coming here and telling us about your passion project.'

With a trembling voice I could not hold back from informing them of one fact that in that moment became completely clear to me: 'YOU ARE DEEP DEAD COMPLETE PERFECTLY WRONG!' Then I effectively talked them through most of the chapters of this book, informing them of the delicious fact that the everlasting fans of Polaroid are far greater in number than they (and any super-clever agency) can even dream of. And that these customers are not generally old diehards but are super-dedicated new-generation photographers just beginning to discover the magic of Polaroid. Young, but certainly not children.

I ended with a passionate appeal to please not destroy the very last chance Polaroid had to carry its former glory into the digital age. Not to treat this invention like a kid's toy. People really loved this new creative material. I had personally talked with many of them; I would buy one; and believe me I am over fourteen years old.

Me going crazy after a meeting with Polaroid top management, documented on Zink paper.

I told them about a meeting with my friends from Moleskine, the amazing Italian brand making stylish notebooks for creative people. The top management there loved the Zink material I showed them, especially as the format perfectly matched the size of their notebooks. They were searching for a clever way for their customers to integrate images in their notebooks, and the little Zink prints with their smart peel-off sticky back seemed to be perfect. Could anyone in the room imagine a better way to zoom Polaroid back into the centre of the worldwide creative community, than to celebrate this material with a powerful analogue partner like Moleskine? Exhausted but unburdened I sat down.

Silence. Then the head of marketing looked at me with a big confused question mark on his face. 'Well, Doc, thank you very much for your enthusiastic presentation and your interesting and truly analogue point of view. But as we are already behind schedule, please let us skip a possible Q&A session. And anyway, that train has already left the station.'

After spending millions of dollars and more than ten years on the development of Zink, the Zink Smart Sheets represented Polaroid's last hope of re-entering the global photographic market.

THE END

Symbolic pictures of
Polaroid's downfall,
taken during my visit to
their factory in Scotland
shortly before it was
closed down.

It took me a few days to recover from this meeting, but with the help of some splendid Bavarian beer and a couple of Weisswürste I got over it. I told myself that the whole disaster was really only about Zink paper and the missed opportunity to transfer at least some of Polaroid's values into a digital world. It wasn't my business, even if I had started to fall in love with this crazy material. So I decided to close that chapter and to focus my full attention on the real stuff: the one and only truly analogue Polaroid film.

But the next shock was not far off, this time even worse than anything I had experienced so far. Just a few weeks after my return from Munich I found out why the train had left the station and Polaroid was pushing the new Zink product so enthusiastically. In February 2008, Polaroid released a short communiqué to the worldwide press:

> Polaroid is closing factories in Massachusetts, Mexico and the Netherlands and cutting 450 jobs as the brand synonymous with instant images focuses on ventures such as a portable printer for images from cell phones and Polaroid-branded digital cameras, televisions and DVD players. [This] will leave Polaroid with 150 employees at its Concord headquarters and a site in the nearby Boston suburb of Waltham, down from peak global employment of nearly 21,000 in 1978.

This was much sooner than planned. In 2004 the decision had been taken to phase out production over ten years, but as demand did not decrease as expected, all the pre-produced film components had been used up after just four years.

So this was the reason for the crazy hurry to launch the Zink. It simply had to be out in the market, shining bright as the new magic material of the digital generation, as the old generation of Polaroid films started to vanish.

Tom Petters, owner and chairman of Polaroid, tried to play down the disastrous impact of the sudden and completely unexpected death of classic Polaroid:

For decades, the name Polaroid has been synonymous with white-bordered pictures, although change and innovation have always been, and will continue to be, a key part of this business. Dr Edwin Land, the founder of Polaroid, reinvented this company many times through its 70-year history – from polarized lenses to eyewear to the iconic instant camera. With the Polaroid PoGo, Polaroid are reinventing the magic of instant printed pictures for the 21st century, and helping ensure the rich legacy of Polaroid lives for another 70 years and beyond.

There had been rumours about the end of Polaroid. But everybody, including the inner circle of Polaroid's management, expected a slow phase-out of production with an end point of 2014 at the earliest. Sales were stronger than expected and Polaroid film still continued to generate high profits every quarter (especially compared to the slow roll out of Polaroid's new digital endeavours).

Looking back I wonder how many hints I missed or maybe even did not want to see. Suddenly the sad looks and mysterious comments over glasses of red wine at the hotel bar from one of our true supporters Paul Telford made much more sense. Paul was head of Polaroid UK and also responsible for all European and Asian analogue sales. He had invited me to visit the Polaroid factory in Scotland in 2007 before it closed. Located in an absolutely beautiful landscape, beside a loch, this was the last factory to produce the small format peel-apart Polaroid film Type 80. It had to close because global demand for this film had simply become too small.

I never really connected with Type 80 film, so the closing of the factory did not bother me at first, especially as Paul explained that there would be no impact on the production of the world's most magic analogue instant films, the integral film types 600, SX-70 and image: these were still manufactured in Enschede, Holland in huge quantities. But the visit was very moving and it still makes me sad to look at the images I took back then (using a black-and-white peel-apart film in honour of this factory and the classic film format).

Polaroid management was not really aware of the tens – maybe hundreds – of thousands of enthusiastic Polaroid photographers all over the world, some of them just beginning to discover their magic material. My desperate speech in Munich had probably not even made it as far as the Polaroid headquarters in the US, but the incredible global shitstorm triggered by their press announcement certainly blew right into their surprised faces.

For the very first time they really felt the depth of passion for Polaroid that was still out there. Unfortunately their announcement had turned that passion into anger and frustration, which was now raining down on their heads. Never would they have expected such an incredible response to a small press release informing the public that an old leftover of the analogue age was finally being put to rest.

Amid this worldwide uproar, even Tom Petters' famous disregard for the analogue aspects of his company started to waver. He ordered a small team of Polaroid experts to look at scenarios for a reversal of the decision to discontinue production. But it was too late for Polaroid to repair this momentous decision. The chemicals needed for film production were almost completely used up and the production of new ones was nearly impossible as all the original, highly specialized factories had been sold and dismantled years before. Finding new suppliers for the original super-complex Polaroid ingredients in order to reverse engineer the famous Polaroid standards from scratch was not a realistic option. So there was no turning back.

You can imagine how I felt. This simply could not be true. Just a few months after I had finally understood all the post-digital value of Polaroid and having built communication and sales highways for this fast-driving new generation of Polaroid photographers, I suddenly had to face the fact that the supply of film, the fuel my business was burning, would soon be cut off. Even if Polaroid management had already told me once before that 'I cannot have everything' I simply could not accept ending up with nothing.

I spent a desperate three months trying to find a way of rescuing the film production. 'Any problem can be solved, using the materials in the room', Edwin Land once said. Well, this problem seemed to be a little bit more complicated. Not even my most powerful contacts in Polaroid management, my wildest letters, my wettest tears, had the slightest impact.

The only Polaroid executive who seemed to care about me was Paul Telford. Not only did he start to make arrangements for large quantities of the remaining stocks of Polaroid film to arrive in my warehouse, he also made this financially possible by working out a very fair consignment agreement. Most importantly (as it turned out) he sent an official invitation to the factory closing event.

My official invitation to the closing of the last operational Polaroid film factory in Enschede, the Netherlands on Saturday 14 June 2008.

Polaroid Closing Event

THE BEGINNING

Polaroid Vice President Paul Telford and myself facing rough winds on our journey to rescue the world's last Polaroid factory.

'Don't go there', my wife told me. 'Please simply accept the fact that this chapter is over. Let's spend the weekend with the kids as planned. Please believe me, even the worst catastrophe can be the beginning of something new, in many cases even something better. So just stop fighting it.' As always I agreed with my wife 100 per cent and promised her (and also myself) that I would accept this turn of events. But nevertheless my analogue heart simply insisted that I go there. Maybe it was simply to feel this catastrophe as intensely as possible. Maybe to collect some last broken pieces of Polaroid magic and use them to build something new. Or maybe I just wanted to say goodbye to an incredible material that I was losing at the very moment I started finally to understand it.

The closing event was a strange mixture of party and funeral. Polaroid employees performed funny little sketches with sadness in their eyes, Polaroid executives and the mayor of Enschede made dramatic speeches. Tears were flowing, along with the famously formidable factory coffee and the even more famous Grolsch lager, and I was starting to wonder if it really had been a good decision to come here.

All of this changed the moment I was introduced to André Bosman, the general manager of the factory, responsible for the final production runs and thereafter for its dismantling. I found out later that he was told to 'take care' of this crazy doc from Vienna, who was probably planning to protest naked on stage, with some anti-Polaroid slogans painted on his ass. Anyhow, almost from the moment we sat down together on a bench, me drinking my ninth beer and André his seventh coffee, our visions, even though they originated in two completely different environments, started to connect perfectly. Almost like finding the last two stones in a puzzle game.

For the very first time I heard the inside story of the last Polaroid factory. Best of all, it soon turned out that André had not given up hope of keeping production alive, even though he himself had been ordered to start dismantling the assembly machines the following Monday, and some other essential machines were already up for sale online. Over the

next few hours I eagerly soaked up every single detail as he carefully explained why he thought there was still hope. He told me that the real estate agency which had acquired the factory buildings had just run out of cash and could no longer afford to tear down the buildings as originally planned. They had delayed this project for ten years, and were currently looking for new tenants. Proudly, André shared the first sample prints he and a small team of specialists had secretly made over the previous months, looking for ways of developing a new film from scratch. He had detailed information about all the remaining original parts and even though some of the most essential ones were gone there was still a reasonable stock of other materials. Moreover, he had already worked out how to rescale the whole gigantic factory of several buildings and more than 200 workers down to just one building and a small initial task force of his very best experts. He even explained that this might be the moment to think about a more modern analogue instant film, avoiding or at least questioning some of the most obvious glitches of the old recipe. His eyes sparkled with energy as he took a deep breath and prepared to dive deeper into this topic.

'Wait, wait,' I interrupted him, 'did I get this right? We could rent this factory for another ten years and keep all the most essential equipment right where it is? And you and your team already have some tests in your drawers that indicate that – contrary to all the official announcements – there might be a chance of developing a new generation of instant film? And by hiring a small team of your very best people we could start this adventure in just one building here, so maybe even at a reasonable cost?'

I had not touched my beer for a very long time, just staring at André, afraid that I might suddenly wake up on the train back from Enschede having dreamed it all.

'Well,' he responded slowly, 'that really depends on the kind of film you are looking for. Reaching the brilliance of today's Polaroid 600 film is probably not a realistic aspiration.'

This was the moment to tell André about my part of the Polaroid universe. Presenting him with this incredible new generation of young instant photographers and their totally flipped expectations, not at all looking for brilliance but on the contrary searching for the truly unpredictable and adventurous nature of Polaroid. I shared with him the astonishing fact that these days the value of films went up as their 'quality' decreased and I even showed him a small selection of favourite 'fire expired' pictures that I always carried with me so as to never forget this essential lesson. 'Dear André, no matter how "bad" the films you

produce may be, the world will go crazy for them. Please believe me, I have sold all of them, creating nothing but happy customers.

'No matter if it's just black-and-white or sepia-like in the very beginning or even if it's monochrome with any shade of colour. As long as people can see their instant pictures slowly appear in their hands, we will be kings of the world. Please tell me honestly the odds of really rediscovering and producing a new instant film based on your experience and your recent findings. Imagine that we can finance the factory and your small task force for one year. It can't be more than a year, as that is how long I can cover demand with the remaining films I just purchased from Polaroid. We really should make sure that all these existing channels don't dry up and we don't lose this amazing momentum.'

André did not need very long to answer the question, and it almost seemed like he had been thinking about exactly this task for weeks already. His short answer: 'One essential building, one year, ten people: 55 per cent chance' made me jump to my feet with a big smile on my face, shaking his hand and whispering with a fast beating heart: 'OK, let's do it!'

We met early the next day, which was Father's Day, normally a sacred family-only day in the Netherlands, to finalize the first steps for this last-ditch attempt. André had the delicate task of stopping the external demolition team from entering the factory on Monday, to protect the machines for at least one more week. A super-delicate task, as this was clearly a severe breach of his orders.

One week of added time that I would use to launch one final attack on the Polaroid decision makers. This time my approach was based on hard facts and the inconvenient truth that – despite their own public statements – there was a better than even chance of keeping this American icon alive, and there was a small group of people ready to risk everything to make it happen.

A delicate situation for Polaroid too, should they not support this final attempt to turn the end into a new beginning.

The legendary closing event did not just treat
me to excellent food, beer and sexy dancers,
but most importantly our fight for the factory
gained the strength it needed by meeting my
new brother-in-arms André Bosman.

IMPOSSIBLE

Our new factory starting team, hand-picked by André to attempt the impossible.

It was the start of a rollercoaster ride.

The first day, Monday 16 June 2008, was a storm of colliding emotional incidents. Polaroid US management called me to say that there was some kind of riot going on at the factory, where André and his team had literally chained themselves to the machines to prevent their demolition. They wanted to know about my involvement in this unacceptable episode. At last I was able to convince them to sit around one table and discuss the next possible steps. At the same time I had to purchase a giant machine, spending more than € 10,000 on a monster that André described as 'a really super-essential special splicer'. This splicer had unfortunately left the factory before the closing event and now we had to buy it back online right away before we were even sure that our plan to rescue the factory would be accepted, because without this machine the whole project would have been in serious danger before it even started.

At the end of that first day, after approximately 2,389 phone calls, André and myself could congratulate each other: the demolition had been re-scheduled, a first meeting with the top management in Enschede was set and instead of the rare vintage motorbike I had been dreaming of I was the proud owner of one of the most ugly and cumbersome machines you could possibly imagine.

Not all the following days went that well, especially as the endless meetings and phone calls with all kinds of high level Polaroid executives turned out to be emotionally draining. For too long it looked as though we would achieve only one positive outcome from all these hours of circular discussions: the executives basically invented our new company name by explaining to us again and again that what we were trying to do was truly and endlessly and honestly IMPOSSIBLE.

As I told them, 'I accept this opinion of yours with all due respect. And we will even name our company "THE IMPOSSIBLE PROJECT" after your recommendation. But please, please do not take away our last chance of finding out if we can turn something impossible into something possible. Edwin Land himself once said: "Don't undertake a project unless it is

manifestly important and nearly impossible." So this is exactly what we want to do. Again, I truly respect and can even understand the fact that Polaroid has decided that the company can no longer take care of its "child" the Polaroid film factory. But please be aware that no Polaroid lover out there in the whole wide world would ever understand that you, the management, would rather kill this child than hand it over to a new family who are ready to take care of it the best they can.'

Like a machine gun André and myself sprayed arguments, calculations, pictures, blood, sweat and tears into Polaroid's no-go wall. At several critical moments Polaroid halted discussions; several times we lured them back to the table. Again we were supported by our friend Paul Telford and maybe more importantly a growing crowd of Polaroid lovers out there, gathering together on online platforms like the famous savepolaroid.com, initiated and mainly driven by my wonderful friends Anne and Dave from New York. For all of us, giving up was not an option.

Nevertheless it became more and more clear to me that even if we did not want to accept it, we were trapped in a dead-end street with absolutely no way out. The final decision was in the hands of exactly the same people who had just taken and officially defended the decision to close the factories, promising the world that there was not even the smallest possibility left of keeping film production alive and that there was definitely no cure for the death of Polaroids. Another train that had left the station.

Of course these people had no interest in giving a small team of enthusiasts led by a Polaroid 'outlaw' and a crazy biologist from Vienna the chance to prove them wrong! Why in the world should they support this? The only thing they could possibly gain from this adventure was egg on their faces.

So it did not look good at all and we honestly ran out of arguments and energy. But then suddenly Mr Tom Petters himself turned everything upside down. And Mr Petters, even if I never meet you – and I most likely never will – please let me thank you from the bottom of my heart for turning out to be such an unscrupulous criminal. Because basically that glorious 24 September, when the FBI invaded your office and took the whole Polaroid top management into custody, was the day Polaroids got their second chance.

Paul Telford called me early the next morning and told me that for exactly one week he himself was responsible for the final decision on the 'Enschede factory case'. 'Doc, we are looking at a wide-open seven-day window to nail down this deal. You know the estimated scrap value of

all the factory equipment is € 180,000. Please arrange the money transfer and try to finalize your lease agreement with the real estate company who now own the building and in the meantime I will prepare all the necessary paperwork.'

Just five days later we were the new super-proud owners of the world's very last Polaroid factory. The new home base and laboratory for our Impossible Project. The bottle of champagne was not even finished when I started to realize that rescuing the factory had been the essential first step but also a very tiny step on our long and winding road of re-developing a new instant film material, and restarting production and distribution, basically from scratch, with just a tiny team and an even smaller budget.

A 55 per cent chance, André had estimated on that bench a few months before. And he kept on warning me over and over again and trying to give me at least a vague impression of how difficult it would be to succeed. Fortunately I had absolutely no idea of the density of the challenges and the height of the roadblocks when we started out. Even ostensibly easy tasks like putting together the final team of the most experienced and valuable Polaroid scientists was much more difficult than expected. Most of these gentlemen had found it very hard to accept the end of their factory and to get used to the fact that all of a sudden nobody needed them any more and that the product they had proudly produced all their lives was suddenly deemed obsolete. Now, just as they started their new lives, an enthusiastically smiling kid, young enough to be their son, who obviously had no real clue what he was doing, was asking them to start all over!

So just putting together the final team and moving all the equipment we needed to our one building took much more time than we had planned. There were only about forty-five weeks left out of the one year we had to restart production. Time was flying and money was flowing out of the factory even without a single machine running, as we had to heat the giant halls and even dehumidify them to keep the production machines in perfect condition.

First of all we had to secure a new source for the heart of our next generation film, both positive and negative. Originally these materials had been produced in Polaroid's factory in New Bedford but of course this facility was no longer available. It seemed to me that the solution was pretty straightforward, as there was another big company out there still producing positive and negative for all kinds of analogue film, even instant film: Fuji. Their analogue business was shrinking, so surely they would be delighted to produce some positive and negative for us, helping

us to keep an iconic material alive and celebrating together the new dawn of instant photography. I could see the headlines!

With the help of the well connected Polaroid president Yuta Ito, I got the opportunity to present this brilliant idea to the head of analogue business development at Fuji. There we sat in the impressive Fuji building in Tokyo and with all my enthusiasm I presented this gentleman with the good news that we really could save the very last Polaroid factory, that we were now planning to restart production and that we would be honoured to order large quantities of positive and negative from Fuji's production facilities which were probably not exactly operating at full capacity, creating a wonderful win-win situation.

Already during my pitch I started to realize that something was wrong from the look on the Fuji manager's face. And before he could say anything, it dawned on me that this office was probably the last place on earth for us to source even a paper clip. Blinded by my hopes and dreams I had not realized that Fuji must have been waiting patiently for the massive Polaroid to collapse, so that they could finally enter the US and European market with their products, the only remaining instant film on earth.

Of course Fuji were not interested in Impossible saving the Polaroid factory and restarting production! 'Thank you very much for the offer of collaboration, Mr Kaps', the manager said, and then he explained something to me in that notoriously polite Japanese way that sounded like: 'If perhaps there were still some experts in our factory who might theoretically answer your questions, I would maybe be delighted to ask them to come back to you with some possibly relevant questions.' Slowly he stood up and walked over to the wall behind him. 'So that your visit has a valuable outcome also, please let me give you this small gift, showing my respect for your adventure.' With these words he took an ugly Fuji calendar down from the wall and handed it to me. The only thing to add here is that all of this happened in November, so the calendar had only two pages left. On the flight back home I crossed out Fuji from my very short list of possible suppliers. What a start!

Forty-three weeks left and counting. Heart attacks of key team members. Containers with the last remaining Polaroid batteries from the US were accidentally loaded on a boat without securing a shady place under the deck, so for two weeks we did not know if this essential last stock of 100,000 batteries would arrive in Amsterdam grilled and destroyed by the sun. Legal issues with the factory. More and more bills and unexpected expenses and most importantly an incredibly long list of all the components we urgently had to source.

A Polaroid taken on the day I realised that Fuji must have been waiting a very long time for Polaroid's magic to stop glowing.

小清水 信弘
KOSHIMIBU NOBUMIKO

1/29/2009

God must be a Polaroid fan, because once again he sent us some support. This time he did not have to involve the FBI. This time he connected us to Harman Technologies.

These experienced British gentlemen had just saved the iconic Ilford production facility close to Manchester, with a management buyout and because of them the world's most iconic black-and-white analogue film materials were still in production.

Howard Hopwood and his team were the first people who really listened to our story and immediately started to search for possible solutions, instead of just pointing once again at all the impossibilities. For the very first time we had real partners and could at least start trying. Working with such experienced people at their small but very well organized facility felt incredibly good, and finally the first little glimpse of light seemed to appear at the end of the tunnel. It did not matter to us that Harman might only be able to supply us with black-and-white materials: the idea of restarting the next generation of instant film with a black-and-white or even sepia material, exactly like Edwin Land did back in 1947, had a sweet romantic aftertaste.

Finally André and his team, most importantly our chemical wizard Martin Steinmeijer, could start their lab tests with modified negatives from Harman. Only a few weeks later I received an email from the factory proudly informing me of the very first result using this completely new process. It was still just a hand-made lab sample, but looking at this very first 'Impossible' really made all of us incredibly proud and happy.

This was the moment when we had the proof in our hands that this Impossible Project truly had a realistic chance of becoming Possible.

Impossible's first stable picture, 19 June 2009, exposed through an old lab test negative of a lady known to us only as Susi.

POSSIBLE

Super-early Impossible
PX test shots, featuring
(clockwise from top left)
André Bosman, my first
impossible self-portrait,
Martin Steinmeijer
and the team from
InovisCoat.

At least in principle! We still had a long way to go. But you can hardly imagine how much this barely visible first photo changed everything. Suddenly it was not just about our dreams and visions any more. Suddenly it was real. Suddenly there was a fresh breeze of hope in these empty and disturbingly silent factory halls.

And it got better the day we first met with another small management buyout from Germany called InovisCoat. Under the leadership of the invincible Dr Jörg Siegel, a small team of experts purchased a giant coating machine from Agfa Leverkusen and re-built it on a smaller scale in Monheim, near Düsseldorf. When we met them in 2009 they were about to start up one of the best and most modern coating facilities in the world, just two hours' drive from our own factory in Eschede. As if that were not enough, we learned in that first meeting that some of InovisCoat's key members had been part of Agfa's secret new business development team back in the early 1980s. They had been tasked with developing an innovative instant film system for Agfa and spent several years on that project but just months before they could launch the product Kodak finally lost a patent war against Polaroid and had to pull all their instant products from the market, facing a huge fine of almost $1 billion. This made it far too dangerous for Agfa to bring their own system to market and the whole development ended up in drawers, archives and of course the heads of the people who developed it. Now some of those very people were sitting just opposite us, willing and able to finally transform their ideas into a real product!

What a combination: an incredible pool of instant photography knowhow and a brand new coating facility not just for test runs but also able to scale up to full production. There was only one more little thing: how to persuade their new investors to green-light the project? Not an easy task, as many millions had been invested in InovisCoat's future, focusing on new technologies like solar foils, light-emitting transistors and microchips. How to possibly persuade these investors to allow resources to be diverted towards the development of analogue instant film, based on an invention from 1947?

Luckily I had already put together a presentation about how the digital revolution had surprisingly converted Polaroids into one of today's most innovative products, attracting young next-generation photographers all over the planet. I threw in several colourful hockey-stick diagrams about the market potential. It worked out and the fantastic InovisCoat team joined our impossible mission alongside Harman.

As it turned out this was a very fortunate combination of resources, as Harman could provide splendid negative sheets, but really struggled with the positive production. InovisCoat stepped in and at the end of 2009 we had the first lab test film packs of extremely promising hand-built Polaroids on our table. Feeling more than nervous, I took a pack, fed it into my favourite SX-70 camera, went outside to catch the last rays of sunlight and pointed the camera at myself. Looking at the picture slowly appearing in my trembling hands there in the factory courtyard was a feeling that I will surely never forget. Yes, we were finally ready to wake up our giant assembly machines and start our first real production runs. It was time to plan our first official press conference and start telling the world about the impossible comeback of our first new generation instant films.

It seemed like we would even be able to hit our unofficial target date of 21 February 2010, the same date that Edwin Land presented his very first films back in 1947. Of course we had to launch in New York, where we just had opened our Impossible office with the everlasting support of the savepolaroid.com heroes, Anne and Dave.

Just hours before we sent out the press invitations, I received an emergency call from the factory: several rolls of the positive material just delivered from InovisCoat had a serious 'sticky problem' and the whole batch of highly valuable ultra-thin layers could not be unrolled without causing heavy damage. After two days of trying everything including heating, freezing, moistening, drying and even praying we had to give up and trash the material, ordering a new batch and delaying our official launch by one month.

Nevertheless the future of instant photography was at hand and once again I have to praise André and his team for this miracle that honestly deserves an eternal place of honour in the pantheon of photography. Considering the fact that we struggled for months to build the company's basic legal and logistical structures and the first real development experiments only started in March 2009, it really and unbelievably did take them only one year to turn something considered impossible

into our first real product. Our true respect and admiration for this masterpiece was also the main theme of our official invitation to the press conference finally announced for 22 March 2010 at our office on Broadway:

> 31,536,000 seconds The Impossible Project had. 31,536,000 seconds to develop over twenty new components that are needed to assemble one single frame containing this magic called Instant Picture. 31,536,000 seconds to prevent more than 200,000,000 perfectly functioning and carefully preserved Polaroid cameras from becoming obsolete.

The very first all-new analogue instant film produced by Impossible was real, rolling off our re-animated assembly line in all its beauty. The first hundred packs were sent to our most active friends and supporters from all over the world, who had never lost faith in us. They should be the very first to experience the new generation of monochrome Polaroids that would forever define the biggest comeback in the history of photography.

Looking at the images they proudly sent us back a few days later made us the world's happiest people. Forgotten were all those endless troubles, doubts, sleepless nights and existential fears; feeling the pulsing magic of these photographs, our impossible dream had come true.

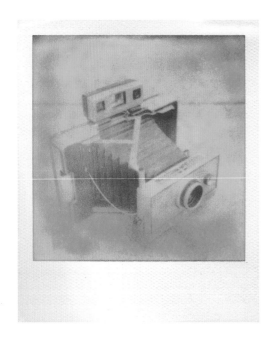

Some of my favourite
surviving photographs
from the first PX global
test user project.

BEWARE
OF HIGH CONTRASTED
SCENE

CREATIVE TECHNIQUES 2.0

From the beginning, our customers had to develop new creative techniques in order to secure the survival of their images. Rudy Force advised fellow photographers: 'Are you tired of seeing your photos ruined? Don't get rid of these photos but make an album out of them. Learn from mistakes, stay tuned, avoid simple mistakes and take better photos.'

Not everybody was as enthusiastic as our first test group of dedicated followers and friends. Howard from Harman called me to say that the board had just reviewed our first test results and these artistic sepia-toned, low-contrast instant pictures, in all their fragile beauty, looked more like ancient paintings to them than anything the Ilford brand stood for.

So there was serious concern that the official presentation of Harman as a partner in this adventure and the usage of the Ilford brand might damage that brand's values. Now I was in the position of telling Howard that unfortunately the train had already left the station. The first 10,000 film packs had been printed and dispatched. At the same time I promised that we would carefully and honestly communicate the true characteristics of our new film to all our customers, so that they would purchase them with the right expectations, and would certainly not be under the impression that they were getting crisp black-and-white Ilford pictures. Howard finally agreed and it turned out to be the right decision as after the press conference Harman and Ilford were buoyed by a wave of positive reactions because of their support for the project.

It really was the main thrust of our press conference to explain very carefully the new nature of instant photography. As I promised André at the factory closing event, these films will not and cannot match the customer's expectations of being just new versions of Polaroid 600 film.

Restarting production from scratch could only succeed if the public understood the true nature of these new films as well as the whole project. It was even to our advantage that because of legal reasons we were not allowed to use the Polaroid name officially and that we called ourselves The Impossible Project.

With almost no resources left and under incredible financial pressure, the only way we could survive was to sell early development-stage film. Back in Polaroid times this would have been nothing but a prototype, to be subjected to another three years of testing by a whole laboratory of experienced scientists before going to market (or not).

We only had a super-small team and we simply had no other choice than to sell these early stage materials with all our love and

understanding, not only to finance the next stages of development, but also because we urgently needed the detailed, fast and furious feedback from all our first customers, who were crazy and dedicated enough to purchase these films. We needed their reports about the way our materials reacted under all the different conditions out there in the field. We had to learn fast and get better on a daily basis in our struggle for survival.

I was confident in this strategy after having successfully communicated and sold tons of heavily expired artistic film materials for years with a very low return rate. I was also aware of the narrow path we were walking with our new materials, especially in the US, where the traditional Polaroid look and feel seemed almost to be included in the genome of society.

This was our one and only chance to reintroduce analogue instant film and also to position it in exactly the right spot. After hundreds of different attempts at product descriptions and product names, we decided this version would trigger the right expectations in our customers:

PX 100 and PX 600 Silver Shade films are today introduced in a limited FIRST FLUSH Edition. This Edition is to celebrate the beginning of a new era of Instant Photography by Impossible.

These very first film packs leaving Impossible's factory in Enschede will provide all waiting photographers with a splendid first taste of the new flavour of Impossible's film materials. These will be developed and expanded further, creating a whole family of new formats, characteristics and blends.

Unlike the highly standardized, traditional Polaroid film, the new Impossible films – and especially the First Flush Edition – will offer a new, broad range of possibilities, characteristics and possible results.

Just like first flush tea, this film material is carefully blended from hand-selected, rare high-quality components and ingredients. Like premium quality tea, it is highly dependent on temperature and can be enjoyed, treated and experienced in many different ways – according to personal tastes and preferences.

The First Flush Edition is a cordial invitation to all interested photographers to join us and discover everything about the possibilities of our first, new material – and to fall in love with the magic of this completely new photographic system. We kindly invite you to join our Impossible adventure and to show the world the unique potential of analogue Instant Photography.

The press conference was an incredible success, gaining wonderful coverage and congratulations from all over the world and selling out the first production runs within just a few weeks. Eagerly analysing the images, experiments and reports from all over the world, we soon had to recognise that the term 'creative techniques' had taken on a new meaning with the introduction of our Silver Shade films. Formerly a way of describing different methods of altering and playing with your instant photographs, now it meant that you had to perform several tricks to get any stable photographic result at all.

The pictures had to be shielded as they came out of the camera, as it turned out they were still dramatically light sensitive in the first few seconds of the development process. Some, especially those taken in very humid conditions, had real problems drying properly which caused all kinds of oxidation processes. Temperature turned out to have a much bigger impact on the new Silver Shade products than back in Polaroid times, especially in the cold. Below about 6°C the results dropped dramatically in contrast and visibility. As if that were not enough we also tortured our customers with a serious collection of different production issues: breaking pods, sticky frame packs, incomplete coverage, pictures falling apart, battery problems.

To be honest all of this was too much for many customers, and I felt terrible about the hundreds of frustrated emails from people who were trying so very hard but simply could not get any results, especially in the US, where we finally stopped selling our films to wholesalers as it turned out that an overwhelming number of traditional US retailers – without having read the product description – expected the new materials to be exactly the same as Polaroid. You can imagine their delight when, after paying double the price of Polaroid, their customers held a strange sepia-toned image in their hands (and sometimes some blue paste too) instead of the bright colourful photo they expected.

A personal series of Silver Shade First Flush
Impossibles, shot on the German island of Sylt in
humid weather conditions. The perfect habitat for
the so-called 'killer crystals', who eat their way
through the photo chemistry.

But we also had the opposite experience, and the whole project was supported by a loyal and dedicated group of customers from all over the world whom we started to call Impossible Pioneers. These people not only bought serious quantities of film in every crazy development phase, they were also the ones who defined the face of our mission as our ambassadors, supporting us not only with their images and feedback but also with new creative techniques and innovative solutions for our most pressing challenges.

They developed shielding techniques and tools to protect the light sensitive pictures as they were ejected from their cameras. They wrote long manuals about how to cut little vents in the back of their images to secure a fast drying process. They even invented a new layer separation technique for the most unstable film patches so not one single pack of these new analogue treasures had to be trashed, no matter how complicated and unreliable they seemed to be at first sight.

Our archive of creative applications, tips and tricks, and especially our library of astonishing pictures, grew every day. And it was the magic touch of these images that recharged our batteries and kept us going with our heads held high.

Eduardo performing an easy Silver Shade technique that enables you to stabilise your image in just six hours.

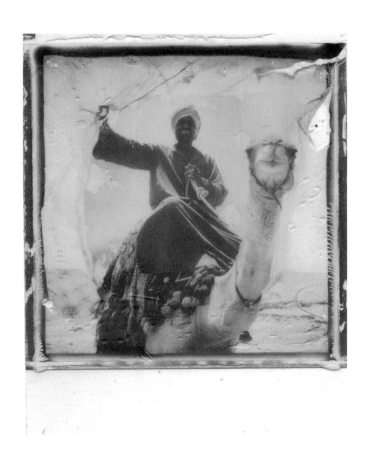

Nobuyoshi Araki, undoubtedly one of the most
important Polaroid photographers of all time, gave us
perhaps the biggest compliment of all time. Right at the
beginning, when many of the world's most renowned
photographers turned their backs on our new Silver
Shade films after their first tests, he fondly explained its
true nature: 'This new instant material is beautiful like
a flower. And like a flower its beauty is very fragile and if
not treated with enough respect and understanding it
soon fades.'

To my delight, my friend David Levinthal also enjoyed playing with our
new Silver Shade materials, even if few of his photographs survive in
such brilliant condition as the one above.

And then there was Jennifer Trausch. Crazy in the most creative and adorable way and for me one of the most powerful photographers pushing the medium beyond all limits.

I met Jennifer in New York, where she was running the legendary 20 x 24 studio in New York, together with John Reuter, mainly working on traditional large-format Polaroid studio portraits. But at night and during her free time she turned into a photographic rock star always looking for new adventures with this crazy monster camera. She was one of the first to simply put the giant camera on a rented truck and travel through the wilderness, stopping to shoot magical black-and-white images unlike any others, documenting the secret soul of America. She was the one who showed me what is possible if you think outside the box and live your dreams, never afraid to get your hands dirty, working harder the harder it gets.

She inspired me to make some hand cut test shots at the factory running our new film materials on the legendary 20 x 24 camera, simply glueing together a bunch of 8 x 10 pods and seeing what happened. Luckily my old friend Jan Hnizdo, master of the last original Polaroid 20 x 24 camera in Prague, also had a curious mind, so he drove his camera to Enschede and we started photographing our factory workers. After some tweaking, the very first giant 20 x 24 Impossible pictures slowly developed on the wall of our factory warehouse.

When I told Jen about these results and my vision of shaking up the overly serious world of large format instant photography, she came over to Europe for a weekend of experimentation with Jan in his studio in Prague, totally taking over his bathroom and shower for all kinds of life-sized transformations, double exposures and negative clearing experiments.

She quit her job in New York, moved to Europe and dived into the new-generation instant project head over heels. The huge slices of our super-complicated material were light sensitive, so we had to cover them with large black sheets. And of course these big versions of our small Silver Shade films also needed special treatment to dry and stabilize. Everything that was an adventure in the small format was simply insane in 20 x 24 format.

Several times Jen almost collapsed during the shoots, because of the ever changing difficulties. She went to Japan to shoot an amazing series of 20 x 24 Silver Shade images with Nobuyoshi Araki; we went to Arles and into the desert and tried to shoot in crazy heat without a millimetre of shade; she tried fashion shoots in Paris, spent weeks with the gentlemen at the factory trying to adapt the monster camera to the new integral film material, moved to Paris and then to Berlin, her hands almost always blue with photo chemicals.

One of the very first large-format Impossible shots, an 8 x 10 Impossible showing our factory workers successfully restarting the giant 8 x 10 assembly machine, rescued from the Polaroid factory in Waltham, Massachusetts.

Overleaf

(Left) The most complicated and sweat-drenched 20 x 24 instant picture ever taken by Jennifer Trausch on the super light-sensitive Silver Shade material in the desert region south of Arles, without any shade.

(Right) A portrait of Chuck Close during the first test of Impossible 20 x 24 material, which I smuggled to the New York studio in my suitcase.

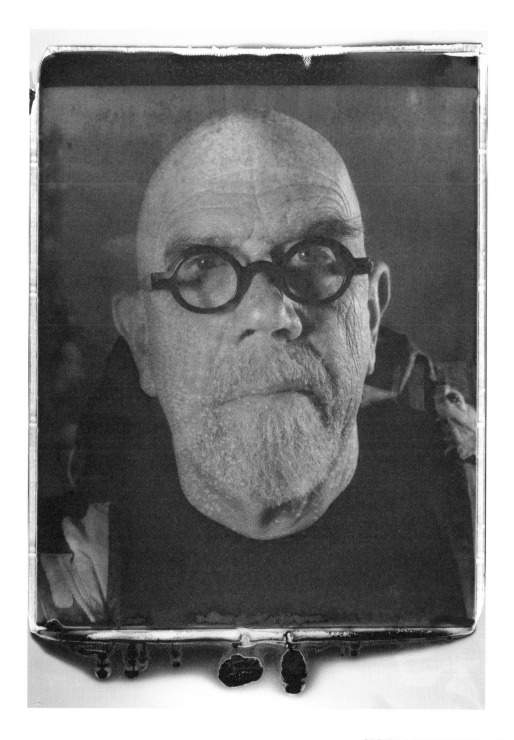

COLOUR

The wizards from InovisCoat had more tricks up their sleeves. By far the biggest one was the existence of a top-secret colour molecule system. These molecules, InovisCoat informed us with a diabolical smile, dated back to the days when they were developing a new instant film system for Agfa. That system never made it to market, but the super complex molecules continued to be produced by Agfa and might now be available for purchase at a reasonable cost. And yes, these molecules did indeed have a good chance of adding colour to our new integral instant film system.

This was simply unbelievable because after the Fuji disaster André and his team had carefully informed me that there were no other options for a new instant colour system. The highly sophisticated process of developing and synthesizing these molecules would involve several hundred thousand euros of investment and it would be two or three years before they could be used. As a matter of fact, we had left colour off our to-do list for at least the first ten years, and decided just to focus on the black-and-white process.

Now to our delight we heard that potentially brilliant new colour molecules were waiting for us at Agfa. We couldn't miss the opportunity and we restarted the instant colour adventure by placing a first small test order.

Looking back, this is maybe the only decision I regret, on my cloudier days at least. That day we woke yet another demon bigger and nastier than even our wildest dreams. We were following the spirit of Edwin Land, but we had forgotten the power and the resources he had back in those days, compared to our own limited means.

In the beginning the colour dye demon just wanted to play with us, demanding our full attention. He took everything we had, but step by step we could control him better. Soon the team sent me the first colour lab tests and only a few months after we launched Silver Shade we proudly presented our first Color Shade materials at Photokina 2010, launching the PX 70 First Flush, the first film to feature just one bluish colour.

The steep and stony road of colour development was paved with endless Impossible test shots, slowly turning from monochrome disasters into bluish experiments.

0510930 221
3 WEEKS

E61 1128

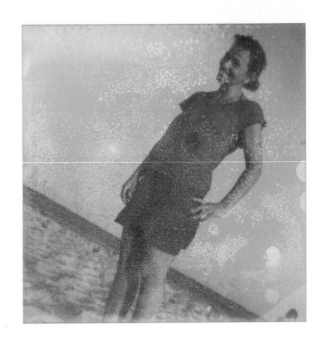

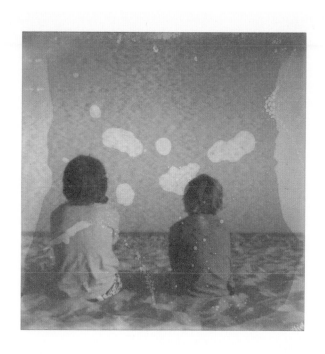

But the colour demon was just pretending to be under control and soon he awoke to menace our company. First it was just a blue shadow that started spreading over some of our Color Shade pictures but then our friends and brothers-in-arms InovisCoat ran into serious trouble as most of their brilliant projects were simply not making it beyond the testing stage and the makeshift development and production of our positives and negatives turned out to be their only real business driver. This was far too small a business to keep their increasingly nervous investors at bay.

We believed in the potential of our products, even if sales were not exploding as we hoped, mostly because of the communication problems in the US caused by the overly experimental nature of our First Flush materials. We started to pre-finance larger and larger production runs of our new materials, storing them in our warehouse. InovisCoat simply could not be allowed to die, now that we were so close to the perfect new instant film!

More and more money was locked up in our warehouse and this started to be a problem not only for liquidity but also because it really put a damper on the development process. We were still at an early stage, when small productions runs are ideal, so that you can change the recipes quickly and adjust the next run as you learn. Now we had to order giant runs and put them out into the market, even though our newest test results were three steps ahead of what we were producing with the old stock. It was still not enough to secure our brave friends' future. We had to find new investors to rescue this outstanding team and their fantastic coating facility for the long term. This was our only chance.

With this new funding in place Impossible was able to enter the next phase and build for the future instead of just trying to solve all the most urgent problems of today. We could fund InovisProject, securing our film production, and we had the resources to bring Dr Stephen R. Herchen to The Impossible Project. He had not only served as Vice President of Research and Development and Chief Technology Officer for Polaroid Corporation for many years but had also led the invention and development of Zink imaging technology, later becoming the CTO of Zink Corp. In short Steven is the scientific godfather and one of world's leading experts in sophisticated imaging processes. With him heading our R&D team the future that barely existed just some months ago was brighter and more possible than ever.

It took almost a year of development before I could finally stare at my own perfectly colourful instant picture, of my youngest son Valentin. He looks totally bored: I had been promising colourful family portraits for months and every time I presented the results they asked 'Are you sure you didn't accidentally load black-and-white film?'

Once again the magic of this material was our biggest advocate, because at the end of the day and after about 2,394 meetings with all sorts of potential investors around the world, it was one of our next generation followers – Oskar – who finally convinced his father to invest: today he defines Impossible's future as CEO.

But even for Oskar, convincing his father was an almost impossible task, as the complete series of first test results could be summarised as a chemical disaster. But this magic image that slowly but unexpectedly developed in the new investor's hands on a sailing trip secured the future of the material.

IMPOSSIBLE CAMERAS

Henny Waanders, without whom the development of Impossible cameras would never have made it out of my visions and into reality.

When we started The Impossible Project, instant cameras had no place on our long to-do lists. There were 200 to 300 million instant cameras out there, most of them still in good shape, which seemed enough to supply all the new-generation instant photographers with several cameras each.

But then we learned that the new customers we managed to convert from digital to analogue had totally different demands and habits compared to when all the most common Polaroid cameras were designed. After the flip, they were looking at instant photography the other way round. And we also found out that at least a quarter of the issues reported with our films were caused by camera problems. Scratched or cloudy lenses and dirty or uneven rollers in most cases.

Nevertheless, André and the rest of the team were totally against my idea of researching possible approaches for a new instant camera. Basically André was right when he warned me that even without a camera project our resources were already stretched beyond all limits. To start another impossible project from scratch simply did not make any sense.

I totally agreed. At least until I met Henny Waanders. Henny had joined Polaroid as a camera engineer back in the 1970s and one of the first big projects he was involved in was the Polavision. Even if this project was not exactly the perfect start, with thousands of unsaleable Polavision cameras scrapped, Henny had a leading role in basically all Polaroid camera and hardware development from then on. He was the first engineer outside of America to be officially allowed to service and repair SX-70 cameras, the most complicated cameras Polaroid ever produced. Henny knew everything about instant cameras and he had already built hundreds of prototypes, firstly in his workshop at the factory and then after his retirement in his garage at home. So suddenly we felt like we did not have to restart the camera project from scratch. Henny already had everything in his head.

When he told me about his life-long dream of developing and building something like an 'open-source instant camera' he had my full attention. 'For many years' he explained 'we basically developed

every instant camera totally differently, which of course is a waste of time as every instant camera at the end must have the same thing: the film processing unit. This unit holds the film pack and after exposure, pushes the film frame between two high precision rollers to squeeze the developing paste between the positive and the negative.

'My dream has always been to develop one perfect universal film processing unit (FPU) totally separate from any camera, and to use this as a standardized platform for building all kinds of cameras. Most importantly we could also make this FPU available for anybody to build and develop a camera of their own. In the age of 3D printing and laser cutting, this might lead to the most interesting camera project in history. Especially for Impossible, where you already develop your films so closely with the customers. What do you think?'

'I think I love you', I had to answer and I booked us both a trip to Berlin to sit down with Achim Heine.

You know Achim from the first section of this book when he helped me to understand the place of analogue photography in the digital world. Achim had not only drawn this world-famous 'flip' diagram, he had also developed all of our marketing materials including all our film pack designs. But deep down Achim was an incredible product designer, most famous for his furniture and especially the first digital Leica camera (lovingly called 'The Brick'). Now I needed his help to imagine the different cameras we could develop with Henny's platform. I knew that the only way to persuade André and our board to start a camera project was some perfect looking high-quality modern instant cameras, efficiently produced on this clever FPU concept from Henny.

Achim and his team compiled a simply breath-taking visualization of three different innovative instant camera concepts and it took exactly ten minutes for these shining renderings to get the board's approval. The Impossible camera project was underway.

In 2012 we launched the first impossible camera based on our new FPU on Kickstarter in order to pre-finance its production. But was it really a camera?

We called it the Instant Lab and it was developed as the tool to finally merge the best of digital with the best of analogue. This crazy-looking collapsible 'tower of analogue power' finally provided the hardware that people had hoped for when Polaroid announced the i-zone Digital Combo.

Basically the Instant Lab is the world's first digital to analogue converter: you select your favourite iPhone picture on screen and put the phone on the Instant Lab to expose it onto the instant film. Within

seconds you hold an instant analogue version of your virtual digital picture in your hands. Without the need to connect the two devices, just by light waves emitted from your powerful retina display and captured by a high-quality lens on our new photo chemistry.

I really love the Instant Lab. It frees all the images I constantly shoot with my iPhone as I cannot carry my favourite SX-70 camera with me all the time. But more importantly this tool brings together the iconic products of maybe the two most influential minds in the history of modern America: the iPhone invented by Steve Jobs at Apple and the magic Polaroid material invented by Edwin Land. Sadly I will never get the chance to show them how perfectly both of their worlds merge in creative harmony.

Originally we had planned to introduce a second camera alongside the Instant Lab. Something that should be exactly the opposite. As the Instant Lab was positioned at the most modern end of photography, connecting analogue with digital, the Impossible Pinhole should be a creative homage to the very beginnings of photography.

After some production issues the 66/6 Pinhole was introduced as a strictly limited edition of just 200 hand numbered pieces at the end of 2014 and it sold out in less than five weeks.

But that was just the warm up for a series of more Impossible cameras and at the time of writing, 18 February 2016, I can taste the future of Impossible cameras by carefully holding one of the first prototypes of the new I-1 in my hands. This will be a camera that perfectly combines the very best of instant analogue photography with all the advantages of today's technology, a significant step in securing the future of this magic material and cementing its position as an innovative creative tool going forwards and not just looking back.

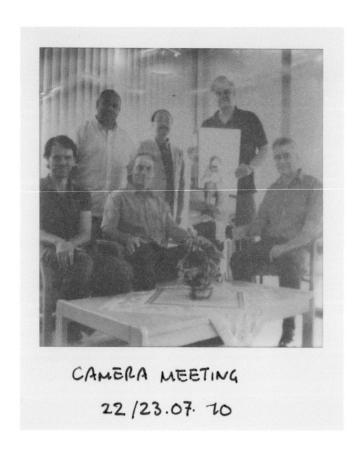

CAMERA MEETING
22 / 23. 07. 10

The first official Impossible camera meeting in July 2010, bringing international experts around one table. In the photo from right to left are Henny Waanders, Achim Heine, Shin Yasuhara, André Bosman, Olaf Marciniak and Andreas Bergmann.

(Left) An Instant Lab exposure of an Instant Lab, melting the borders between digital and analogue photography. (Right) One of the first shots on the 66/6 Instant Pinhole, a camera hand-built in an edition of 200 by Supersense in 2014.

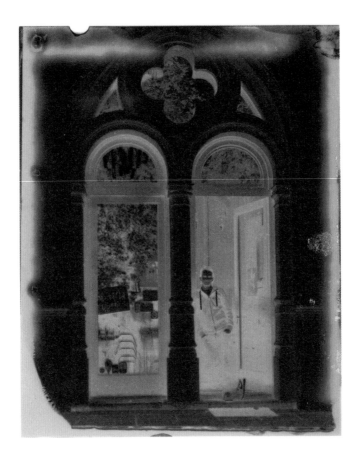

Talking about the future of this magic material, I don't want to close this book without showing these two images, shot on New55, a surprising but incredibly promising reincarnation of the legendary Polaroid 55, the Holy Grail of instant photography, which produces a negative as well as a positive print. The New55 is developed and hand-produced by a small team around the crazy inventor Robert Crowley in a warehouse factory in Ashland, Massachusetts. It feels like the future of instant photography has just started.

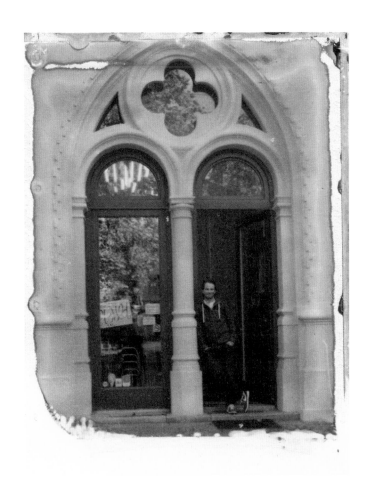

POLAROID?

A Polaroid snapshot from a big global press release party in Hong Kong, back in the days when the new owners were still dreaming of re-establishing Polaroid as a big player in the photographic industry.

Maybe you noticed that in the last few chapters I have intuitively avoided the word 'Polaroid'. This permanent quandary was initiated when we signed the purchase agreement for the last Polaroid factory which included the strict legal clause that we would never be allowed to call anything produced at this factory by the name of Polaroid.

This is understandable from a legal and licensing point of view, and it also turned out to be essential for us to clearly separate our new materials from the classic Polaroid film. But at the end of the day it was ridiculous, as the brand name Polaroid had merged with all instant film products in an inseparable synonym long ago.

I talked endlessly about the new generation of analogue instant film without the slightest mention of Polaroid and tried to persuade the world to refer to 'Impossibles'. But no matter how hard we tried, the customers and even the most well informed journalists celebrated the fact that POLAROIDS ARE BACK

This was a very quirky situation as Polaroid itself had survived the Tom Petters disaster and the proud new owners were ready to conquer the world. So for the first time in history (as far as I know) an iconic product was out there in the market but separated from its also-still-existing brand.

What was Polaroid doing at that time? Unsurprisingly, the Zink train had not gone very far since it left the Munich station in 2008, but it was still rolling and slowly moving away from the first ridiculous children's toy direction. Lady Gaga's stint as creative director officially came to an end in 2014, without any of her designs having seen the light of day.

The new owners, winning a thrilling auction for the brand with a final bid of $85.9m, had their heads turned by the magic of Polaroid in their first year of ownership. Leading experts in licensing and asset stripping, they became Polaroid managers, giving themselves crazy titles, a passport to the world of art, design and fashion. They probably lost millions, and soon they certainly lost interest.

As soon as the owners finally stopped trying to be the new Polaroid and focused on what they had always been good at, the business started to stabilize and turn a profit. Today Polaroid is a small company, mainly

employing lawyers and with a very clear focus on just establishing and running a clever worldwide licensing business with more or less carefully selected partners around the world. And that is all.

When I look at it set down in writing this way, it all looks pretty clear and clean. But to be honest, these years were really challenging for me and The Impossible Project as we were deeply involved in Polaroid's struggle for a new identity. Even if we tried very hard to emphasize our complete independence from each other, in reality this was not practicable.

Lady Gaga urgently needed cameras and films for her videos, so Polaroid had to call me to provide them. Giovanni Tomaselli at Polaroid decided to produce a new analogue instant camera and after several months he realized that they also needed some film so once again I got the call. At the end of the day they took a shortcut and just re-branded an old Fuji instant camera with the Polaroid logo and started selling Fuji Instax films as the new Polaroids. Thankfully that was one of Giovanni's last acts but these cameras are still sold by Polaroid and every time I see one I have to recall my Fuji meeting from 2009. All in all a very painful and frustrating experience, watching the Polaroid management running around in circles, high on this magic drug called Polaroid but without the slightest idea of what it was really all about.

Only one manager was different and my due respect goes out to Mr Jeff Branmann who did his very best to guide me through this crazy new Polaroid universe and who shared the vision of finally reconnecting the brand's most iconic product with the brand.

In the end we were just a few hours away from making our dream come true. After a small warm-up project introducing a Polaroid Classic product line of accessories, we finally had an acceptable licence agreement for our films on the table, approved by both sides and basically ready to be signed. From now on we would finally be allowed to call our new film the same name everybody was already using: Polaroids.

(Left) Jeff Branmann, part of the new Polaroid management, who tried his best to support my vision of reconnecting Impossible film materials with the iconic Polaroid name. (Right) The last living design fossils surviving in my refrigerator, reminding me on a daily basis of how close we came to making this happen.

Achim and his team developed a new series of pack designs and we prepared the press invitations and booked our flights to New York for a launch on 22 March 2013. At the very last minute it fell through. The flights and the press conference were cancelled and with the exception of a few films surviving in my refrigerator, all the wonderful new packages were scrapped.

As much as it hurt at the time, I realize that at the end of the day it really does not matter what we call our films. And maybe all of these contracts and agreements and royalty discussions were just too complicated from the start.

ALL THAT REALLY MATTERS IS THE
MAGIC MATERIAL THAT CAN BE
CAREFULLY FILLED WITH YOUR MOST
PRECIOUS MOMENTS AND CAN BE
CALLED ANYTHING YOU LIKE. I AM
MORE THAN PROUD TO HAVE HELPED
KEEP IT ALIVE, TOGETHER WITH A
COUNTLESS NUMBER OF OTHER
CRAZY MINDS. WE ALL SHARED
THE CONVICTION THAT THIS MAGIC
MATERIAL DESERVES THE CHANCE
TO CAST ITS SPELL ON MANY MORE
GENERATIONS OF PHOTOGRAPHERS.

YOU TOO, I HOPE.

YOUR POLAROID

LAB SAMPLES

ROLL FILM

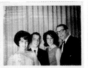

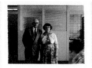

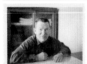

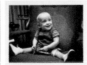
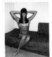

TYPE 100

236

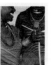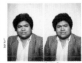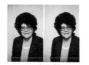

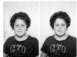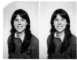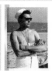

4 X 5

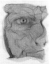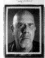

8 X 10

20 X 24

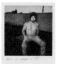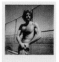

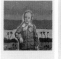

SX-70/600

IMAGE

TYPE 80

500

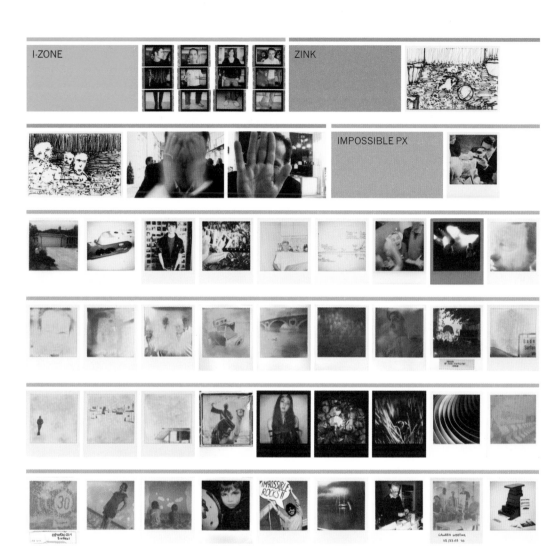

I-ZONE

ZINK

IMPOSSIBLE PX

NEW 55

DEDICATION

This book is dedicated to Jennifer Land DuBois, whom I have never had the pleasure of meeting personally. Nevertheless I thought of her many, many times. Not only because she was the one who initiated the invention of one-step photography one evening back in 1943 in Santa Fe. I can imagine that she knows better than anybody else in the world how incredibly and absurdly demanding and absorbing the magic of Polaroid can be.

Starting the Impossible Project as an enthusiastic and stubborn biologist and Polaroid dealer on a mission to keep one of the greatest inventions of mankind alive had an unexpectedly overwhelming impact on me personally, and the sudden loss of time I had for the ones I love. The Polaroid mission demanded much more blood, sweat and tears than I was expecting but which finally I was more than eager to spend.

In this respect the book is also dedicated to my wonderful children Hannah, Kaspar and Valentin, with the promise to not only dedicate warm words to them, but also more time.

Last but not least, this book is dedicated to Eduardo Sir Schlexi Webmeister and his blind dog because without him (the man, not the dog) this book would just be fourteen chapters long and the world would just have those disgustingly ridiculous Fuji Instax pictures left.

This is a very long list of dedications, and I have not even mentioned my wife this time which of course will cause me a lot of trouble, even if she would never show me her disappointment, even pretending that she never did read this book, because basically nobody is really interested in what a failed biologist and lousy father has to say about the 'magic' of Polaroid anyway. HA! But darling, I already dedicated to you my diploma thesis about the eye muscles of the American hunting spider *Cupienius salei*! Don't you remember? It took me ten years to write that thesis and I dedicated it to you alone! So that surely has much more value than this little book.

One more note: I promised to write this book and to be honest that made me a little nervous. Especially as my English vocabulary only consists of approximately 527 different words . . . although, mathematically speaking, they could be combined in a lot of different ways. 'Don't undertake a project unless it is manifestly important and nearly impossible' as Edwin Land would have put it. The fact that nevertheless you are holding this book in your hands is down to the support of Andrew Dunn, publisher at Frances Lincoln, who not only invited me to give it a try but also agreed to my approach of making it an personal picture book, with the main part played by Polaroids alone.

ACKNOWLEDGEMENTS

pp. 8, 11, 90, 112, 116, 117, 120, 123, 125, 127, 130, 133, 135, 136, 139, 140, 141, 144, 145, 147, 153L, 162R, 163L, 169, 171, 172, 175, 178, 182, 189, 192, 202, 203, 212, 214, 215, 216, 217, 219, 226, 230, 232 © Florian Kaps
pp. 12, 63 © Patrick Nagatani
p. 14 courtesy of Anne Bowermann
pp. 18, 19 The Polaroid Historical Collection, MIT Museum
p. 20 © Cromwell Schubarth
pp. 50, 74, 75 © John Reuter
p. 54 Reproduced with permission from The Ansel Adams Publishing Rights Trust. All rights reserved. Image file supplied by

George Eastman Museum
p. 57 © Maurizio Galimberti
p. 58 © Chuck Close, courtesy Pace Gallery
p. 59 Museum of Fine Arts, Houston / Gift of Manfred Heiting, The Manfred Heiting Collection / Bridgeman Images © 2016 The Andy Warhol Foundation for the Visual Arts, Inc. / Artists Rights Society (ARS), New York and DACS, London
p. 61 © Jasper Zwartjes
p. 65 © Elsa Dorman 2016. This work is licensed under the Creative Common Attribution-NonCommercial-ShareAlike license.
pp. 66, 207 © David Levinthal
p. 67 © Max Rada Dada

pp. 68, 209, 210, 211 © Jennifer Trausch
p. 69 © Co Rentmeester
p. 70 © Beppe Bolchi
pp. 73, 205 © Eduardo
pp. 76, 77 © Ralph Steadman
pp.78, 81, 82, 83 © The Photography Collections, University of Maryland, Baltimore County
pp. 86, 87 © Alfred Weidinger
pp. 102-3 © Antonio de Moraes Barros Filho
pp. 128, 155 © Norah Goldenbogen for POLANOIR
p. 148 © Spitoco for POLANOIR
pp. 150, 151 © Stefanie Schneider for POLANOIR
p. 153R © CenteCente for POLANOIR

p. 154L © Grant Hamilton for POLANOIR
p. 154R © Lars Blumen for POLANOIR
pp. 162L, 163R © Marco Christian Krenn
p. 164 © James Matthew Carroll & Natasha Keens
p. 167 © Siegfried "Hoizi" Holzbauer
p. 184 © Jennifer Rumbach
pp. 196, 197 © Polanoid & SilverShade Pioneers: CDR, zveliakine and emilie79
p. 198 © Rudy Force
p. 206 © Nobuyoshi Araki from the exhibition IMPOSSIBLE PROJECT SPACE tokyo
pp. 228, 229 © Peter Kubelka